INNER LANDSCAPES

… it may not be the native land that inspires

… the country of the heart may be elsewhere.

– Helen Constantine, translator, *French Tales*, Oxford University Press

INNER LANDSCAPES

15 New Zealand Artists with Canterbury Connections

Canterbury University Press

First published in 2009 by

CANTERBURY UNIVERSITY PRESS
University of Canterbury
Private Bag 4800
Christchurch
NEW ZEALAND
www.cup.canterbury.ac.nz

ISBN 978-1-877257-85-8

A catalogue record for this book is available from the National Library of New Zealand.

Essay *Justin Paton*
Interviews *Sally Blundell* PhD, Dip. Jour
Studio and portrait photographs *Diederik van Heyningen*
Works photographs *Diederik van Heyningen* (unless otherwise credited)
Book and cover design *Aaron Beehre*
Image selection *Melinda Johnston* MA, BA (Hons)
Project liaison *Mark Prain*

The *Inner Landscapes* project was devised and directed by *Lorraine North* MA (Hons), BA
for the Canterbury Arts and Heritage Trust

Excerpt on page 2 reproduced by permission of Oxford University Press

Printed in China through Bookbuilders

Canterbury University Press and the Canterbury Arts and Heritage Trust gratefully acknowledge a primary grant in aid of publication from the Canterbury Community Trust. For additional project support we thank Adrienne, Lady Stewart; Joyce Hamilton; Creative Communities; and Professional Arts Services.

Preface

The Canterbury Arts and Heritage Trust's *Inner Landscapes* project, comprising book and exhibition, arose from a wish to raise awareness of New Zealand's many nationally and internationally acclaimed living artists who have strong links to Canterbury, mainly through the University of Canterbury School of Fine Arts.

The project did not aim to identify a definitive or complete group, but simply to select a cross-section of artists working in a variety of media over a period spanning three generations, in order to provide an overview of contemporary art practice associated with the School of Fine Arts. It is hoped that the glimpses and fragments revealed in this book and the original works in the exhibition will generate increased interest in the work of not only the selected artists, but also the many other artists of excellence who share the same association.

To a large extent the shape of the project was determined by the artists, and a main point of difference between this and other art books is that most of the text consists of the artists speaking in their own voice. Alongside the striking photographic portraits and splendid examples of the artists' work, these verbal self-portraits provide an insight into contemporary art practice that is direct and personal. All involved feel a sense of privilege that the artists participated with such a high degree of openness and honesty.

It is almost a decade since an art publication has grouped artists associated with the Canterbury region, and such books have typically related the artworks in some way to the geography of the area. However, as the title suggests, in this book the focus is on the artists and their inner worlds; on their ideas and reflections, rather than their relationships with an external environment. In the words of Ronnie van Hout: 'At high school … I thought modern art was unfathomable and a complete mystery. Then there was this one moment when it all made sense, when I understood that art wasn't about realism, but about ideas.'

This book is testimony to the richness and diversity of these ideas expressed through a wide range of styles and content. The reader can delight in the finished artwork, but also in discovering more about the processes behind it, as the artists share their views about art and how these affect the ways in which they approach their own work.

Lorraine North
Project Director
Chair, Canterbury Arts and Heritage Trust, May 2009

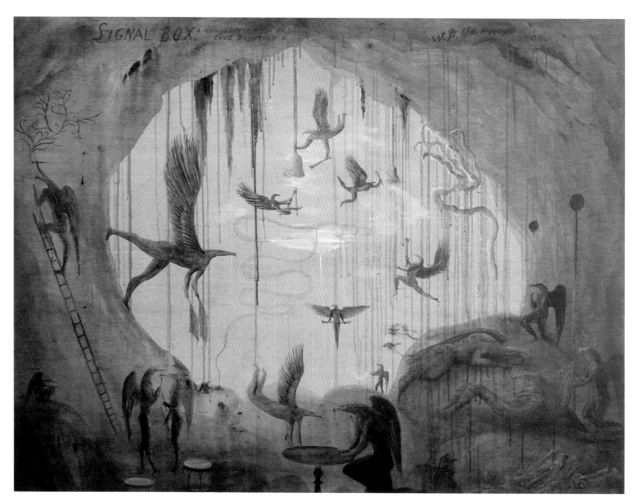

Bill Hammond *Signal Box*, 2008. Acrylic on canvas, 1350 x 1800 mm
Courtesy of the artist. Private collection, Auckland

Somewhere Else
Notes on 'art from Canterbury'
Justin Paton

Does Canterbury art exist? Of course art gets made in the province of Canterbury every day. Paintings are painted, prints are printed, photos are photoshopped, craft is crafted, and – perhaps not every day, but regularly – installations are installed. But is it right to call them Canterbury artworks, or even artworks by Canterbury artists? What if the artists lived in Canterbury for a long time but recently left? What if, like provincial rugby players lured towards a new franchise, they lived elsewhere all their lives and just arrived? What if a major artist happens to make his paintings on the exact border of Canterbury and Otago, with one foot planted on each side of the provincial divide? The example may be ridiculous (the border consists of a very wide river), but doesn't it reveal, by extension, how ridiculous it is to herd artists inside lines laid down long ago by government surveyors and local body authorities?

This is a book about artists and Canterbury, about people who have lived, taught or studied here, but it prudently resists any temptation to call them all Canterbury artists. Leaf through these pages looking for Canterbury artists and you'll find yourself standing in a crowd composed entirely of exceptions. Ronnie van Hout left in 1997 and has lived for the last nine years in Melbourne, with a year-long stop in Berlin. Joanna Langford lived here, but now works in Wellington, and has occasionally been found in Cappadocia and South America. You might assume a painter such as Don Peebles stands on surer regional ground, since he's lived and worked in this place for most of his extraordinarily focused career. Yet Peebles is, if anything, the most 'international' of these artists, one who has headed out each day to his Ilam studio to resume his conversations with Piet Mondrian and Paul Cézanne – European painters who

feel, in the paintings Don makes, as near at hand as neighbours. Anyone who talks too obsessively about 'location' in the vicinity of these artists is almost certainly pushing their luck. So it's wise of this publication to stand well back from these sticky matters of place and identity. Since I've been invited along to provide this introduction, I should probably follow suit …

But instead I'd like to push my luck, and see where things end up.

The trouble with regional groupings is the way they so often are accompanied by a kind of defensiveness. When someone announces loudly that they are champions of art from Canterbury, what they're usually saying simultaneously is that they're suspicious of art *not* from Canterbury. In this scenario, the honest and industrious locals are always being pitted against Auckland's frantic followers of fashion or, worse still, the jet-setting smoothies of the international art world. Unfortunately, the desire to avoid this kind of narrow-minded allegiance to the local can produce an equally narrow-minded allegiance to the international – an assumption that whatever comes from Leipzig or London must by definition be better than what's emerging in Papanui.

Both responses are understandable. I remember visiting a well-known artist in his London studio and listening politely –

too politely – to his impressions of New Zealand. 'I've been as far as Sydney,' he said. 'You travel forever to get to this country clinging to the edge of the world, and then you travel forever across Australia to get to this city that clings to the edge of that edge. And New Zealand is beyond that!' Here, clearly, was a mind organised along the same imperial lines as the 'what's on' listings in the back of London's *The Art Newspaper*, where the sections read, in sequence: United States, United Kingdom, Rest of Europe, Rest of World. Now a gloomy reading of my studio encounter would take it as proof of New Zealand's irrelevance, evidence that we are still stuck in the cultural equivalent of a cellphone dead zone – inaudible on the Blackberries and iPhones of the international art world. But the real lesson, for me, is that there is no such thing as 'the international art world'. London and New York are provinces like any other, with their own obsessions, their own codes, their own blind spots and delusions. And they never reveal their provincialism more fully than when they remark on how far away the other provinces appear to be.

It's not that physical distances don't matter. It's just that our sense of what that distance means depends entirely on where we stand. Distance, like scale, is not a locked-down fact but a live and shifting relationship; things are only big or small or near or far in

relation to other things. New York may look daunting when you're in Sydney, but try the view of Sydney from Auckland. And if Auckland looks imposing from Christchurch, try the view of Christchurch from Ashburton. The point is not to stand in the departures lounge pining for the true art cities that exist somewhere else. Nor is it to set up your easel on Old Tram Road and start painting nor'west arches exclusively. What's wanted – well, what I want anyway – is a feeling for the way the near and far, the known and unfamiliar, meet and move in relation to each other. I don't want to be pinned down by an art that says *here and here only*. I want to be *oriented*, wherever I find myself. Because even if you do head to Old Tram Road for that full-strength Canterbury landscape experience, there's a good chance you'll have travelled there in a Japanese car, listening to American music on the car radio, wearing clothes made in China, and looking out at the world through eyes conditioned by centuries of European landscape painting. And a convincing contemporary landscape ought to be alert to these contradictions. When Philip Trusttum floods images of his grandson's playthings with the unhinged energy of Japanese manga comics, or when Hannah and Aaron Beehre summon the ghost of American television characters amidst the English oaks of Hagley Park, this is what they're up to –

alerting us to the figments and fragments of other times and places that are always part of our here and now.

I nearly represented Canterbury once. It was 1980 and I was one of two tryouts from the Shirley Rugby Club for the Under 9 Canterbury side. Neither of us made the cut; it was quiet in the car on the way home. To 'represent the province' was the dream, supposedly, of every kid alive during that Ranfurly Shield-obsessed era. But what does it mean, by contrast, to represent Canterbury in art? Is it like 'representing' the province in sport? Do Canterbury artists open their shows in Auckland with that crusading sense of regional pride – with a determination to seize the top slot on the leader board?

They don't, and the reason for this is simple. A player represents the province in the most straightforward sense. But for artists this word 'represent' has to have a different and larger meaning. To represent is also to re-present: to reimagine, reshape, recast. It means taking the image of a familiar place or thing and handing it back to the world altered. When a player represents Canterbury on the field, their efforts are meant to strengthen a sense of place that was already rock solid. But when artists get down to the task of re-presentation, I think the very opposite occurs: our sense of a

Ronnie van Hout *The Disappearance*, 2007. Digital video (still)
Courtesy the artist

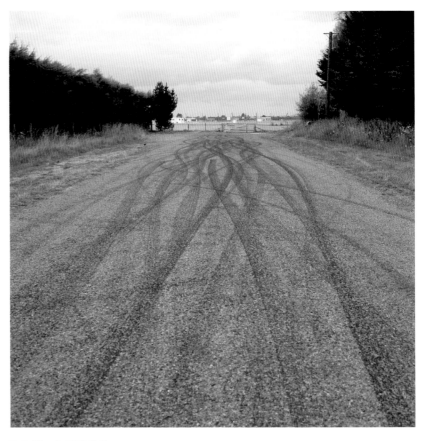

Rob Hood *(BBM) Burnouts*, 2007. Framed lamda print, 1300 x 1300 mm
Courtesy the artist and Jonathan Smart Gallery

place is unsettled and expanded. In the presence of any vivid new proposal about place, we should feel less grounded, less certain, less sure of where we are. In fact you might say that, until the work of representation has got under way, place in the richest sense does not exist. It hasn't been summoned or coaxed into detail. It's textureless, lifeless, dead flat.

Flatness, of course, is one of the things that anyone representing Canterbury has to contend with. The part of the province most people see and inhabit is almost relentlessly horizontal: a vast plain formed over millennia by the fanning shingle of mighty rivers. This flatness lends itself to jokes (heard the one about Christchurch and bad coffee – both are flat, white and cold), and it also drew one of New Zealand writing's grimmest urban descriptions, from Janet Frame, who wrote that being in Christchurch was like living at the bottom of a well whose walls were made of sky.

But, as Frame's image perversely proves, this flatness can serve just as powerfully as a spur to the imagination. The city's formidable flatness has the effect of endowing even the smallest rise, curve or hollow with drama. The joy of the Avon River is not its weeping willows or pretty punts but the way it puts a kink in the city's street plan, creating a few loops and dead ends in what might otherwise be an unrelieved grid. As a kid being driven from one place to another on dead-straight suburban roads, I remember how certain places in the city seemed mysteriously charged: a shadowed bend in the river near Banks Avenue that we called 'the spooks'; the scraggy north end of Brighton beach, where the blown-back dunes were always laying claim to half the road; those odd suburban edges further north where the frames of fresh houses are shadowed by old dark forest; and, of course, the caves along the road to Sumner. These were places where you got above or below the line of the horizon, where you had a chance to look back at the place you lived in from some eccentric or secret angle. They offered relief, in both senses.

And artists offer this too. They coax the flatland of the familiar into some kind of imaginative relief. Coming back to Christchurch 18 months ago, I found myself involved in an unexpectedly protracted hunt for a place to live. After weeks spent criss-crossing the grid, the city started to merge in my mind with those dismal slideshows that play in real estate agency windows, and I began to crave moments of relief like those just described. So I started to accumulate, from among the art I came across when I wasn't chasing real estate, a list of alternative views. The list began with the view from the swampy lowlands of Mairehau, where Ronnie van Hout seems to be digging a grave or escape route in his video *The Disappearance*. Then there was the view from the wide empty

Tony de Lautour *Underworld 2*, 2006. Oil on canvas, 2180 x 5000 mm
Purchased by Friends of the Christchurch Art Gallery, 2007 [photographer: Brendan Lee]

back roads of McLeans Island, where Rob Hood photographs the burnouts left by those hotly debated 'landscape artists' – boy racers. There was the view from the hollows of the volcanic landscape that is Banks Peninsula, where Pauline Rhodes runs and leaves impermanent markers of her passing. There was the view of the peaks along the volcano's rim, which I didn't know were called the Seven Sisters until encountering Lonnie Hutchinson's artwork of the same name. And there was the view from the region's limestone caves, where Bill Hammond has located his remarkable recent homages to the Maori rock drawings of the South Island – some of the most remarkable 'landscape art' to be found here (see page 8).

Above all, there was the view back towards the city from the Summit Road at night, which I think of whenever I see Tony de Lautour's vast painting *Underworld 2*. When Hollywood directors like Michael Mann show us the Los Angeles city grid glimmering beautifully at night, it's usually a prelude to bad news. The camera is about to dive down through that phosphorescence and into some murky recess of vice. In de Lautour's painting, by contrast, we receive the beauty and the bad news simultaneously – a city grid of symbols that's at once ominous and beguiling. I'm not sure whether de Lautour was thinking of Christchurch's famed 'dark underbelly' as he made this work, or whether he was thinking of

Christchurch at all. But his painting brings home maximally one of the dilemmas faced by any artist seeking to portray place today, especially if that place includes a city. How do you make it fit? How do you get it all in? *Underworld 2* vividly evokes the contemporary syndrome we might call scale panic – the feeling that there's so much information, so many opinions and positions blazing away in ignorance of each other, that it's impossible to reconcile the big picture with all the little ones. But even as the work withholds the possibility of total understanding, it offers a compensating pleasure – the pleasure of getting lost.

There is art that represents a place by portraying it: a painting of a river, a photo of a street. There is art that excavates the place itself and puts it to work in art, as when Andrew Drummond imbeds gleaming chunks of Westland coal in his sculptures or Peter Robinson spreads earth across a painting. There is art in which place is present quietly or tacitly, as in the perfect abstract paintings that Gordon Walters crafted for two decades in suburban Christchurch, to little local acclaim. There is art whose chief debt to a place may be any one of thousands of practical things, from cheap studio rental to the presence of an art school to the fact the relatives live just down the road. And then, thank god, there is art that reminds us not to

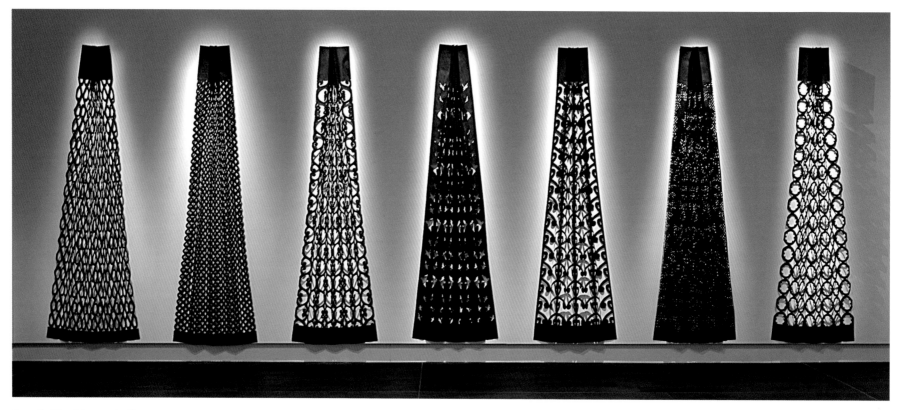

Lonnie Hutchinson *sista7*, 2003. Black building paper, 2500 x 7400 mm approx
Collection of the Christchurch Art Gallery Te Puna o Waiwhetu, purchased 2003 [photographer: Brendan Lee]

take place too solemnly, as when Philip Trusttum embellished his rollicking rural paintings of the 1990s with very funny 'signs of the local' – generous smudges of Waimate sheep-shit. Nothing compels an artist to represent a place. It's not necessary to do so, just possible.

Say the words 'art from Canterbury', though, and certain landscape images start to move past the mind's eye, like sights rolling past the windows of a weekend tour bus. There's a country church and a dark green shelterbelt. There's a braided river and a distant range of sun-bleached hills. There's a railside shelter, an endless succession of nor'west arches, and plains, plains, plains. But for any such tour to be credible today it has to travel to other places – past the glowing green virtual hedge fashioned by Hannah and Aaron Beehre, across the abstract circuitry of Darryn George's paintings, around the intestinal twists of Julia Morison's *Myriorama*, through the toy-bright, epic clutter of Philip Trusttum's latest paintings, and on out into the consumer landscape of disposable stuff through which Joanna Langford trawls. Do these views add up to one coherent vista, a comprehensive take on how it is here? Far from it. Fresh drivers keep taking the wheel and turning the bus down little-known side roads. Each new driver tells a story through the on-board intercom that wildly contradicts the last one you heard. And some of them choose to stop the bus and talk about somewhere else entirely.

The strange and encouraging thing is that the stories from elsewhere are no less illuminating than those told locally. Art illuminates where you are even when – in fact, especially when – it comes in from somewhere else. The Canterbury Plains look more interesting to me – less plain and less settled – after peering at the dry and unnamed dreamscape in Séraphine Pick's *Good Morning, Morning*. And a nor'west arch has never looked stranger to me than on the day in 2007 that I encountered Langford's *the quietening*; it was as if a rogue weather system had blown armfuls of discarded plastic bags all the way from a suburban mall to a High Street gallery, where they became a cloudscape only slightly longer-lived than the real one I could see out the window. These artists remind us that we don't just live on the ground. We also live in our heads, memories and imaginations. Place in the richest sense encompasses both geographies, a merging of inside and outside like that described beautifully by writer Rebecca Solnit in her book *A Field Guide to Getting Lost*: 'Place, which is always spoken of as though it only counts when you're present, possesses you in its absence, takes on another life as a sense of place, a summoning in the imagination with all the atmospheric effect and association of a powerful emotion. The places inside matter as much as the ones outside.'

Justin Paton is senior curator at Christchurch Art Gallery Te Puna o Waiwhetu.

Hannah & Aaron Beehre

Hannah & Aaron Beehre

There's the collaboration that happens between us, and then there's something like collaboration that happens between us and the situation or the gallery or the space. We don't usually come up with an idea and then find a site. The site happens first. We think about how we want the work to react to that particular space, the lighting, the textures. Then there's the whole experience of walking into a gallery – that can be quite a sensory experience. So we examine ideas for a specific show, although there is a certain language, a thread that carries through.

We do like process. We'll swap ideas then walk away and think about it and come back and turn over more ideas. It's that process when you talk about the issues and find solutions to what you're doing that is really exciting – the practice rather than having a game plan. It's more exciting than one person having complete control – you keep that curiosity, you don't end up with what you think you're going to end up with. And we like to see the work grow. If you got someone else to make it, it would end up looking just as you expected it to look; there'd be no surprise. That's the most important thing – that it remains interesting to us, that it's a new experience for us as much as to anyone viewing it.

In the really early work, when we were connecting formalism with popular culture, there was something about that connection that was quite exciting. It's that idea of magic, of taking someone somewhere and making a space that becomes another space. We enjoy creating something that is quite simple, editing a work down to a more simple idea that's more pure in some way. We haven't become obsessed with technology – we don't find out what the technology can do and go from there; we decide what we want to make and then see if we can make the technology to do it. The digital works are actually the most simple form of digital, lo-fi. You can feel sophisticated looking at it but it doesn't need to be sophisticated technology-wise. If it got too bogged down in technology we'd get bored – it's really important that we get something new from the work.

Criticism is quite interesting: we tend to explore it, try to understand it. Some people might say the work's too decorative, so our next work will be as decorative as we can make it, just to work that out.

When we first started working together there was a fad for coming up with a group name and we did think about pseudonyms, but there's a transparency in keeping our individual names. The history is all there.

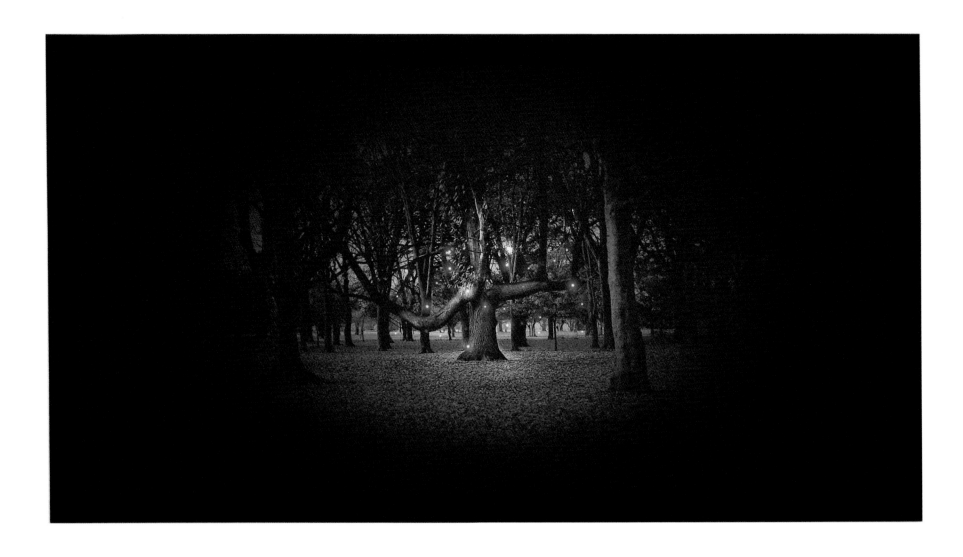

Opposite page:
Postcard to Dr Jacoby, 2008. Framed sublimation painting, LCD, computer hard-drive, software, sonar & audio sensors, 1100 x 2005 mm
Collection of the artist [photographer: Aaron Beehre]

This page left to right:
JS.02.03 'The Hedge', 2003. Digital projection with audio sensor, variable dimensions
Collection of the Christchurch Art Gallery Te Puna o Waiwhetu, purchased 2003 [photographer: Brendan Lee]

Avon Lights, 2008. LED lights, audio sensors, variable dimensions
Collection of the artist [photographer: Aaron Beehre]

AWO 09.05, 2005. Acrylic on board, 1000 x 1000 mm
Collection of the artist [photographer: Aaron Beehre]

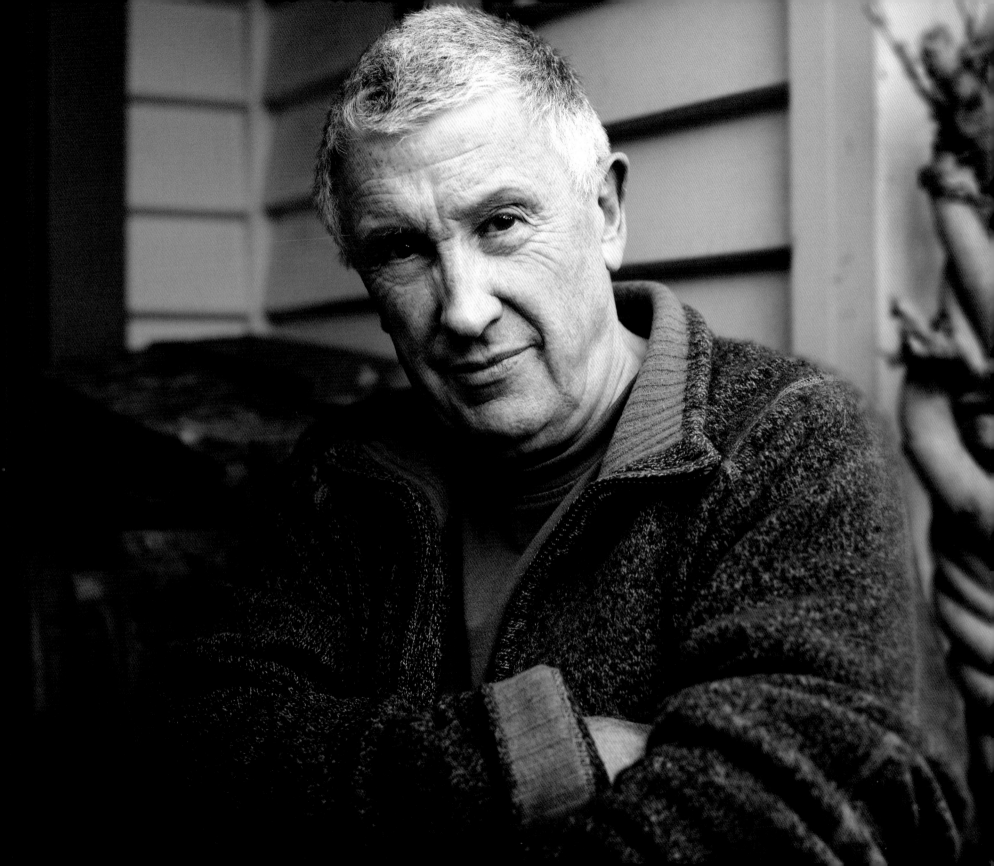

Barry Cleavin

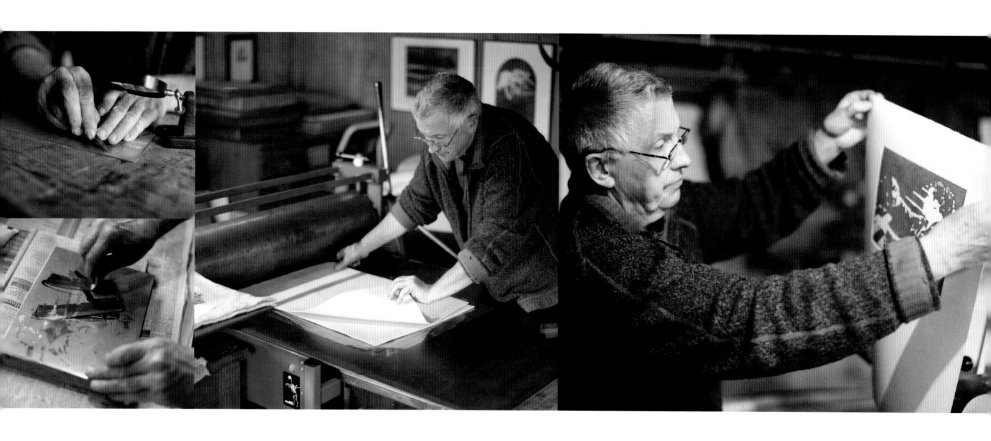

Barry Cleavin

Printmaking is narrative and storytelling. I decided at art school that to say the sort of things I wanted to say I'd better go to the print-room. I couldn't see how to story-tell as a painter. Books played a part. It was through books that I found that I had that graphic tendency. If a print is any good it's got something to say – it might be elegant and pleasant but it tends to darkly rumble. It has a bite. I couldn't see a way of doing that in the painting department, not because of a lack of tuition but because I had a printer's disposition, just as a painter has a painter's disposition.

It was tough in a way. You'd have painters being painters and sculptors being sculptors, and then there were filmmakers and graphic designers – these Big Art people were figureheads of everybody's perception of what an art school was. They'd come trucking into the printroom and look rather disparagingly at the people attending to good housekeeping – with printmaking you do have to do things in an approved recipe-type manner. Painting is close to being epic and Wagnerian. It's a huge enterprise, whereas mine is more introverted, more reclusive. It looks at things very close, but it also examines things from a long way away. If you look at a print by Rembrandt or Ensor, they have an intimate way of addressing you – they don't grab you by the scruff of the neck and fling you across the room like a Pollock or a de Kooning.

In 1972 I worked with Gabor Peterdi, a Hungarian printmaker who was head of printmaking at Yale. He said you make a print, even if it's only one impression off a plate, because that gives you the look you want. A pen drawing or a pencil drawing wouldn't have done it. If you look at Piranesi – he couldn't have done those things as a painter. Each print is a contract between you and the surface to get the result you want.

Like typographers, you have different typefaces for different purposes – there's an appropriate line for drawing an ear, an appropriate weight of line to express a fingernail. It's also about trying to wedge words and images together. Comics have tried to break that boundary between words and images. Robert Crumb was telling more about the truth of America at the time than, say, de Kooning. First you have to look at what the print is telling you, then you look at the sum total of how the lines mesh together, the textures, the patterns, the inferences of colour. New Zealand doesn't have a great sense of graphic literacy but you've got to accept that some people can read it – if you add education to that, this whole graphic literacy thing will gallop! Just as people go to a movie and come out with smiles or sadnesses, with something to help them get on with their lives, it adds to that compendium of information.

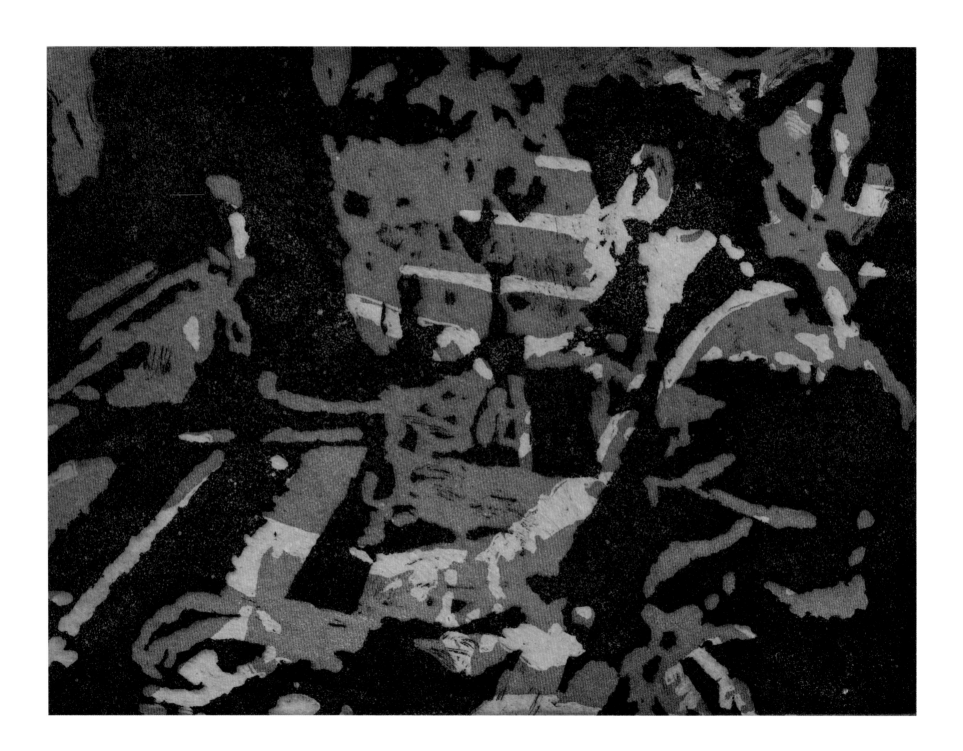

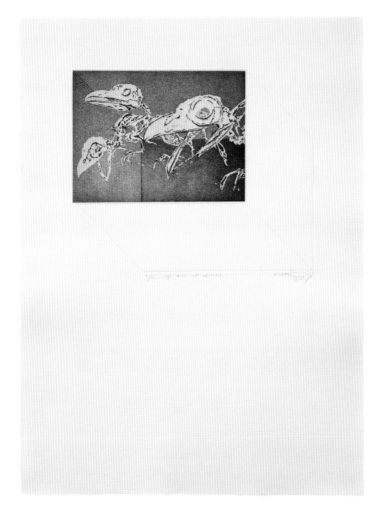

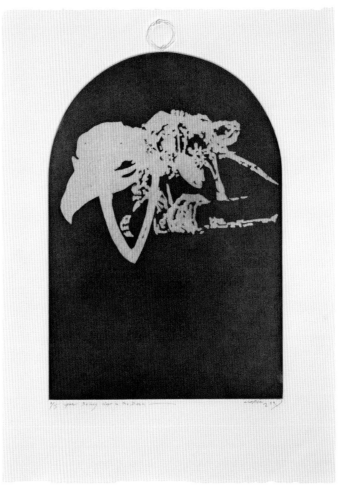

Opposite page:
Chromatic Variation 6, 2008. Aquatint, 175 x 235 mm
Collection of the artist

This page left to right:
A Box of Birds, 2007. Etching, aquatint and emboss, 245 x 275 mm
Collection of the artist

Upon Being Kept in the Dark, 2007. Etching, aquatint and emboss, 435 x 275 mm
Collection of the artist

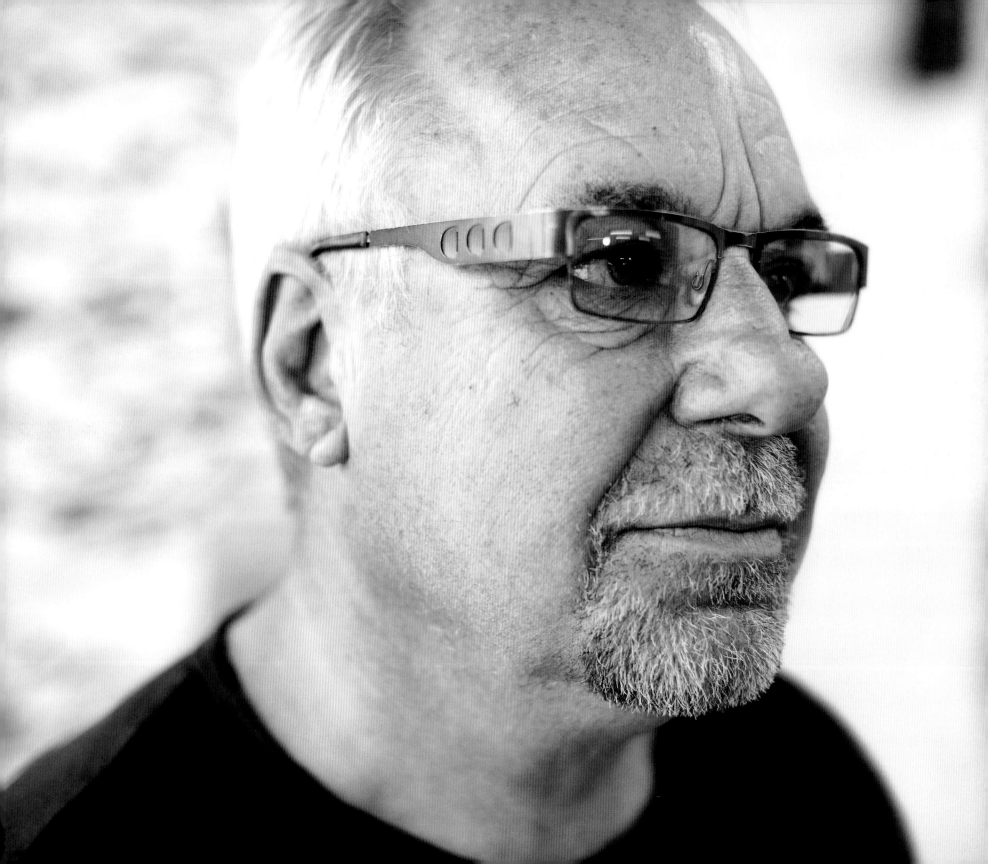

Neil Dawson

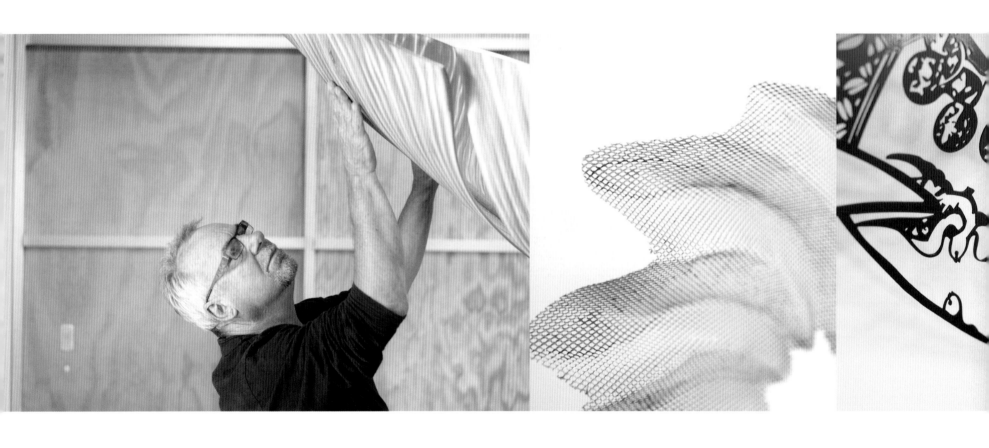

Neil Dawson

The sculpture department at art school was a really interesting place. If you went into the painting department and started building things you'd be in strife, but if you went into the sculpture room and started painting there'd be no problem. You could do photography, performance or installations. My predecessors in the sculpture department, Carl Sydow and John Panting, I admired immensely – Panting especially was brilliant. I've always been interested in Russian constructivism, still am, and in British sculpture – people like Gormley and Kapoor. When I was working at polytech I taught 3D design, drawing and drawing systems. I was fascinated by 3D design. I found it easier to explore sculpture ideas within that context than in the sculptural context – even at art school I was interested in drawing in sculpture. I also taught toy-making. I liked the simplicity of toys, their inventiveness, and the fact that they don't have a function apart from play.

My first show in a dealer gallery was *House Alterations* in 1978. It was an exhibition of 15 tiny houses, little 3D objects hung at different heights and made of different materials. The idea was to make something that was easy to identify, so there was no question about *what* it was – it was about *how* or *why* it was. Even then there was that idea of hidden outlines, of substance and absence, of adding to an experience without adding components. I knew I wanted to get away from objects on plinths – a plinth always ends up looking like a person, whatever you put on top – and heavy sculpture takes up human space and blocks your passage. With the suspended works, like *Echo*, you don't have that – you have an experience that's unique, that's always changing. That experience of viewing is so important – people passing them, glimpsing them, building up a series of glances over time. People construct their own experiences of them that way. And I think you can alter mood through sculpture. It can change the psychology of a site.

When I go into a space I try not to concentrate on any one thing. I absorb, absorb, absorb, take photographs, talk to the client, look at the history, the weather, the functions of the space – it's a weird process of osmosis. By the time you've done that, something's emerging, something that's nodding to the Victorian silverware or the rose windows or whatever else you find. It's a very intuitive process. There are heaps of possibilities but still you have to go back to the basics of structure, design and scale. With public works you're not going to please everybody but you try not to offend anybody, so you have to have some knowledge of the culture. Even with Maori and Pakeha cultures, I look at the things we have in common or I go back before anyone was here, which is what I did with *Chalice* and *Ferns*. Still, each time I come home, I'm struck by the temporary nature of our structures, how young we are from a built environment point of view. I think that brings up lots of opportunities.

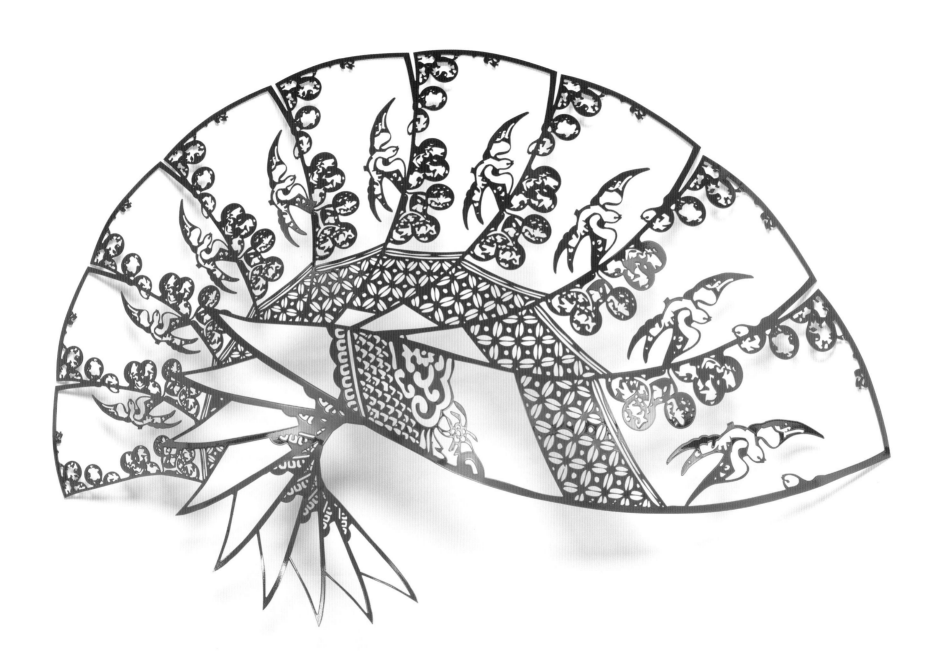

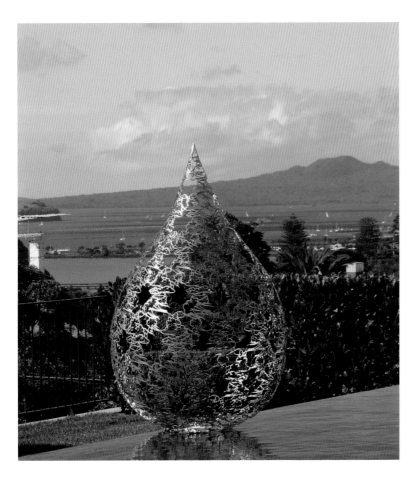 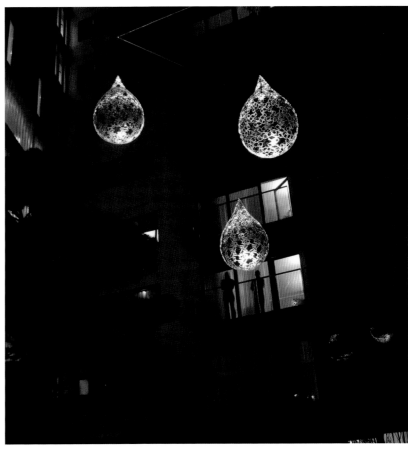

Opposite page:
old, new, borrowed, blue, Plate 12, 2008. Painted steel, 680 x 965 x 120 mm
Courtesy Milford Galleries

This page left to right:
Raindrop, 2006. Stainless steel, 1100 x 650 x 650 mm
Private commission, Auckland [photographer: Neil Dawson]

Raindrops, 2006. Stainless steel, 1800 x 1200 x 1200 mm
Lumiere Building, Manchester, England [photographer: Neil Dawson]

Tony de Lautour

Tony de Lautour

There's a feeling with art that most things have been done before in one way or another. Some people find that restricting but I think it gives you the freedom to get on with doing the work you want to be doing. I don't intentionally set out to do a particular series of work – it just evolves out of the last lot of work and where I find myself. Often an idea will start off with something quite small and then all of a sudden a whole lot of possibilities start unfolding in front of you, so you go down one line of inquiry until you're satisfied with it. For a while I was very interested in New Zealand history. It wasn't something I'd been taught at school and it was a way of finding out about the place you live in and your attitude towards it. Then for a while people would say, how come you don't do those paintings with thick paint and kiwis holding syringes any more? But I'd done them. You can't go back. If you did, you'd be doing it from the position of knowing as opposed to finding out. It's not the same as doing the work when you're on the edge of doing it. In some recent paintings I've brought back the little mountains which I haven't done for years – it just seemed appropriate for the work I was doing – and there are still elements of branding and globalisation that I was looking at in the mountain logo works. With that series, as soon as people started suggesting different logos I decided it was time to finish. The New Zealand references in my work are less overt now but some of the imagery, some of the signs and symbols still remain, so it becomes like a ghost of that inquiry. You have all these images in a sort of back catalogue, lurking in the conscious or unconscious. Some you forget about, and some you rediscover and think, I could reuse that.

I don't think you can be anywhere and not be influenced by where you are or what's around you. Even the studio environment can affect your work. There are a lot of angular, geometric shapes in my recent work and from my studio the view is all rooftops and angles. It could be an architectural thing – working in a more open space, the paintings are more open – and a lot of advertising is quite geometric. Some of these shapes are now standing in for letters – like a lightning bolt 'S' or a triangle 'A'. There's some personal narrative but it's not obvious. I'm interested in work that's open to interpretation – there's never one reading of art; and time, context and place can alter the reading quite dramatically. An artist will put images together in their own knowing way and if you can put images together there's no point in going through all the written or verbal language. Besides, if you over-talk something, it ruins the mystique.

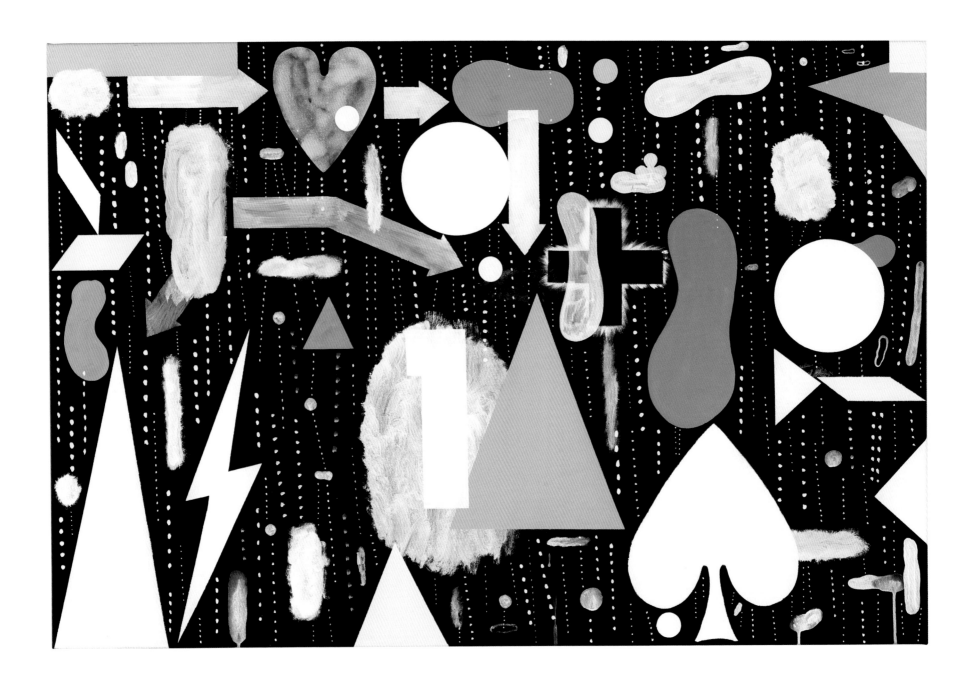

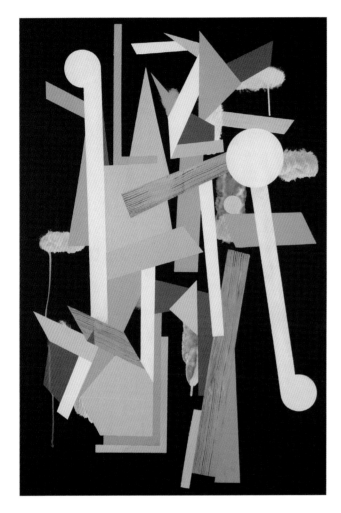 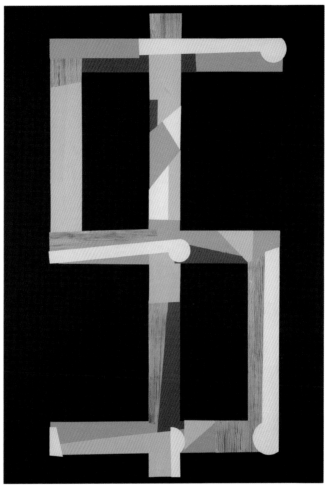

Opposite page:
Night Time 1, 2007. Acrylic on canvas, 800 x 1200 mm
Collection of the artist

This page left to right:
Leave Her, 2008. Acrylic on canvas, 1200 x 795 mm
Collection of the artist [photographer: Mark Gore]

$, 2009. Acrylic on canvas, 1520 x 1060 mm
Collection of the artist [photographer: Mark Gore]

Andrew Drummond

Andrew Drummond

When I started making my work I didn't know where it was going but, looking back now, the interests I had when I was doing performance work – interest in the animal and the relationship between people and the landscape and the idea of healing – still hold me. The form is different, but those ideas are still there. I think there's huge potential in the idea of sculpture functioning as a machine that heals the landscape, of the redemptive aspect of art – Joseph Beuys had that idea of the closing of the wound. One of the ideas behind *for beating and breathing* was to make an installation that made that metaphorical connection between the body and the land. The idea of the relationship between the machine, in terms of medical interventions, and the body breathing in and out and the beating of the heart, is essential to this work. As an installation it is a mystery, a conundrum, but also incredibly straightforward. You don't need an art language toolkit to understand it. You just need to be able free yourself and lose your apprehensions. I'm still very interested in that idea of suspension and wonder. When you're used to it you can be playful; when you're not you become apprehensive. The thing is, we want to understand everything – if we don't we write bibles – but that understanding is already there, we just have to allow ourselves to be open. Art has the power to help us do that but there seem to be so many constructs formed around trying to make art have relevance. I think the notion that art has a nationalistic role is incredibly dangerous.

One needs quiet to make art; you need space and freedom. Working in Scotland during 1974 was hugely affirming but I also felt this huge attachment to New Zealand – emotionally and physically. I wanted to work here. I like working in a social way where I'm just one person in a team of people with specialist knowledge or abilities who help me take an idea to the point where it's finished – but it is a silent place. Artists do feel anxiety, I think, but in a sense that anxious place is the only place you can be. How do you begin to protect that place and protect the things that are in there for you? You have to keep questioning everything. You have to be in a constantly shifting zone where you look forward to unpredictability, rather than run away from it.

My spinning works are simple structures responding to wind speed and the fickleness of the wind. I'm interested in the way the wind works on things – we think it should be constant but it's not, it's not predictable. *Tower of Light* in Wellington is a very city type of machine. It's a machine that measures the wind – measuring has always been central to my practice – and it's incredibly pragmatic. The windier it gets the more neons light up. If it's a green day it's still; if it's a red day it's incredibly windy! That's one of the wonderful things about making sculpture – giving form out of nothing, making something long-lasting, bullet-proof, but also elegant and beautiful.

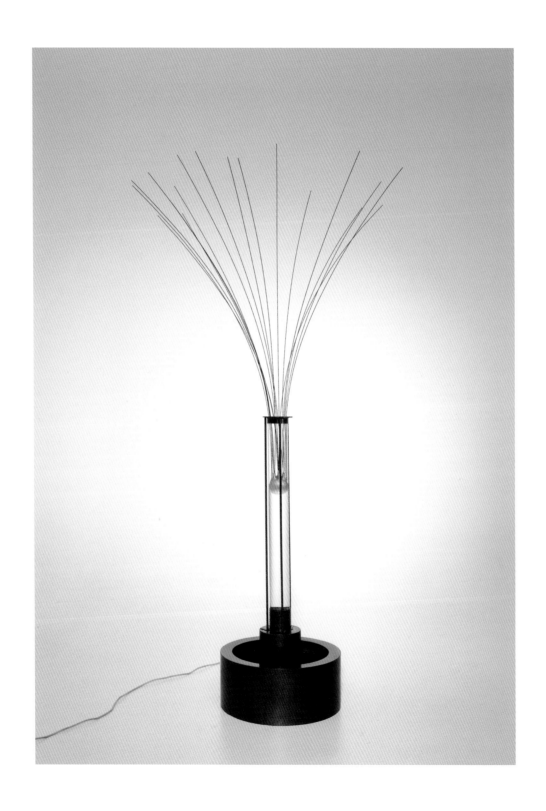

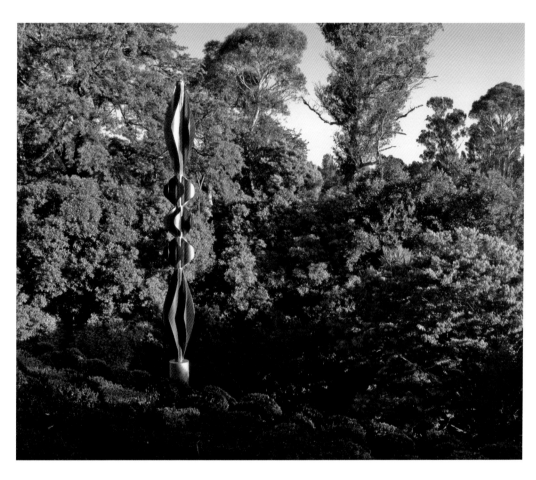

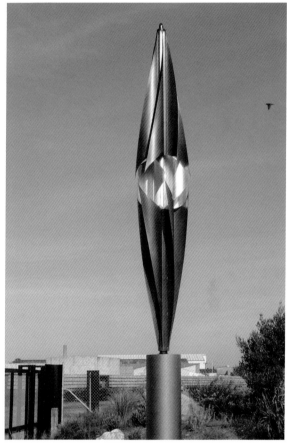

Opposite page:
For Rising and Falling, 2006–2009. Brass, glass, water, gold leaf & control system, 2700 x 500 x 500 mm various
Collection of the artist

This page left to right:
Vertical Form, Counter Rotating, 2007. Stainless steel, steel, patina & paint, 7000 x 600 x 600 mm various
Collection of Sir Miles Warren, Ohinetahi [photographer: Brendan Lee]

Kowhai, Counter Rotating, 2008. Stainless steel, steel, patina, gilding & paint, 5000 x 600 x 600 mm various
Collection of the artist [photographer: Andrew Drummond]

Darryn George

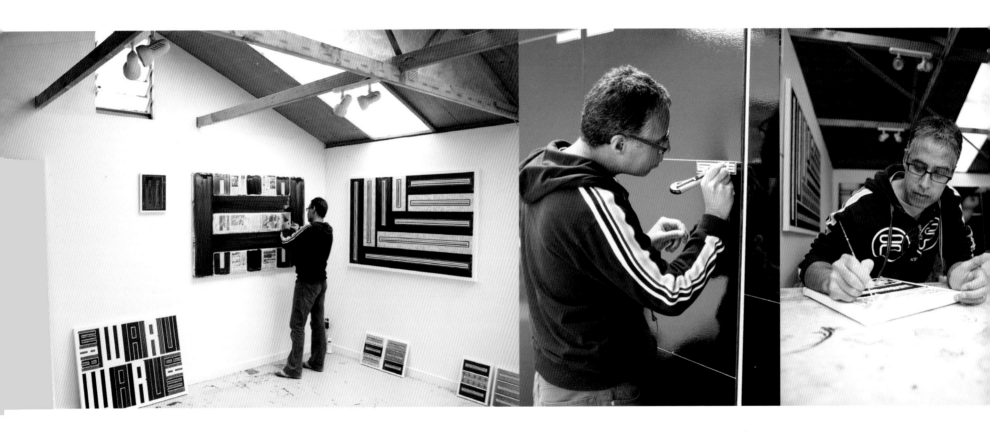

Darryn George

At the end of art school a group of us were taken to a marae at Whangara. It was the first time I'd seen a fully carved meeting house. I was totally confused – I didn't know the concepts or the narratives. I'd come from a minimalist aesthetic – my art education was dominated by American abstraction and Italian artists like Mimmo Palladino, Francesco Clemente, Enzo Cucchi – and here was all this detail and decoration. The kaumatua could see I was confused. He said my Christian faith was a solid foundation for decision-making and life principles, but the art in the meeting house was knowledge created by my ancestors – vocabulary and information that I could use to tell my own story. That was really liberating. I started looking at the poutama design, the stepping design on tukutuku panels. These were the steps taken by Tane or an ancestor into heaven – there's a conceptual connection there to my Christian faith, but they also looked like a Jonathan Lasker painting. After that I started reducing my colour palette back to red, black and white. That helped me concentrate on form, content and surface.

There's just so much you can do with paint: you can use a paintbrush like a pencil; you can paint with thick layers; you can really trowel it on and get that ribbed effect. My work is about surface and textures, but it's also about three-dimensional space and flat space. If I use gloss and matt paint, the matt comes forward and the gloss goes way, way back. Antoni Tàpies is a really interesting artist – he used plaster and all kinds of bits and pieces to make gritty surfaces – he was all about responding to accidents. While I like his surfaces, my process is completely different – it's all figured out beforehand and generated on a computer. As I get older I realise there are certain aspects of the practice that I have real strength in – design, scale and building up surfaces – and others that I am willing to let others be involved in.

I think of a meeting house now as a place of stories and knowledge passed down through the oral tradition, but my knowledge came from going to university and reading texts. When we did *Pulse*, the big meeting house at the Christchurch Art Gallery, I thought, why not make a meeting house that had great big books down the side? For that work we had to rely on scale and colour. In the text works, the text is the most important part. If you think about the whole project as saying something about what I believe, text helps clarify things. When people look at an abstract work and they see a word, that sparks off a whole new set of readings. I see McCahon as a kind of prophet – a John the Baptist in the wilderness proclaiming what painting can do. He wanted his painting to speak. I'm not a confrontational person, I'm not politically out there. For me the Maori words are just a gentle way of being true to myself.

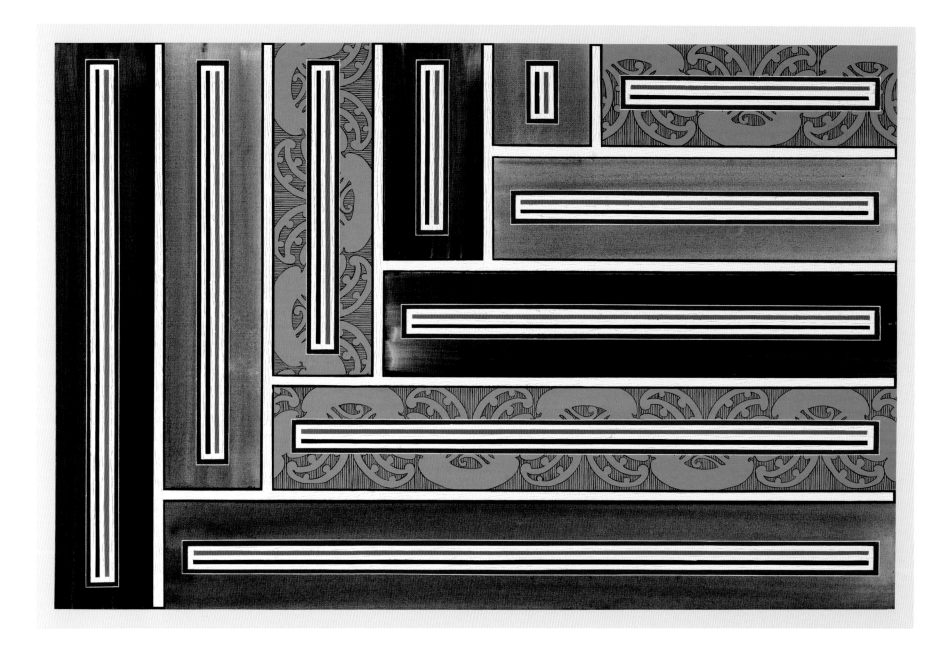

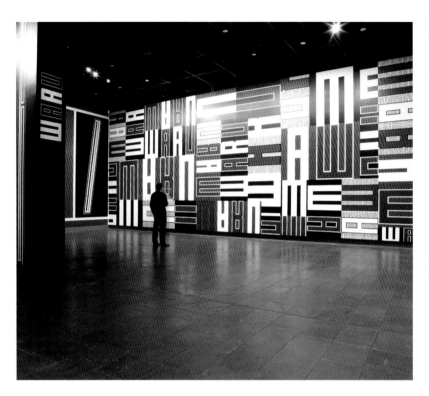

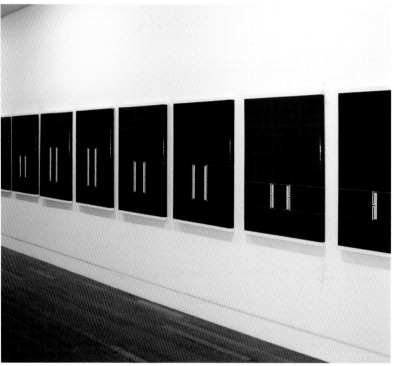

Opposite page:
Kete, 2008. Oil on canvas, 1000 x 1500 mm
Collection of the artist

This page left to right:
Pulse, 2008. Acrylic on board, approximately 300 square metres
Courtesy of the Christchurch Art Gallery Te Puna o Waiwhetu [photographer: Brendan Lee]

The Equaliser, 2006–2007. Oil on canvas, 10 panels each 1200 x 800 mm
Private collection [photographer: Darryn George]

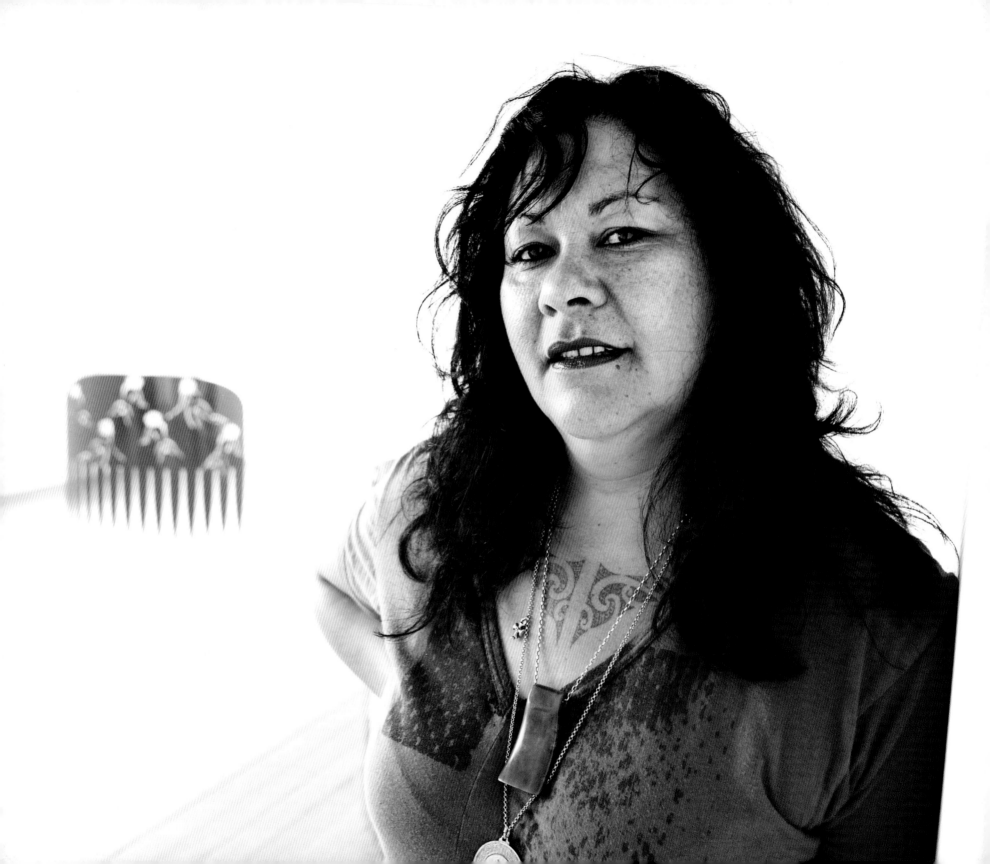

Lonnie Hutchinson

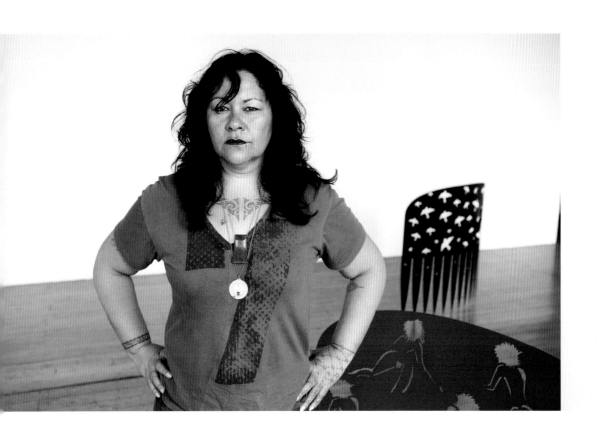

Lonnie Hutchinson

History is the kaupapa, where it all comes from. A lot of my work has to do with Ngai Tahu history and my mother's Samoan history. I'm trying to overlap – not hybrid, but different worlds. I'm trying to heal past wounds but sometimes you have to break them open before they can heal. I was born and brought up in Auckland – my Dad was a panelbeater and I was always in the workshop, banging around – but I was taught to prepare kava and to dance by my mother. When there was any Pacific fundraising event, I would be the taupo and have to dance. My mother used to do the same thing in the islands when she was young. Dad was more removed from his cultural roots – his grandmother was born in Kaikoura but her mother died in the influenza epidemic so she was sent up north. It wasn't until Dad's sister did some research that we found out our whakapapa. And then there's the English/Scots side – my Ngai Tahu bloodline comes from a whaler, Tame Norton, who married a Maori woman.

I live in Auckland now but Te Wai Pounamu is still my turanga-waewae – it's where my ancestors are. Their blood's in this earth. I remember someone at a hui saying that no one can hurt you on your rohe. I've kept that with me, even when I'm travelling – I am a bit of a gypsy.

My first cut-out work was when I was artist-in-residence at Macmillan Brown [Centre for Pacific Studies, University of Canterbury] in 2000. Two artists I knew were using oilstick on building paper and I thought I'd have a go. Later that night I started cutting the paper. It just happened. That work became *Double Ranch Slider* – I hung it at the Lava Bar, then showed it at CoCA. No one else was doing it. When I was at art school Warren Viscoe said your signature as an artist was really important. You had to be consistent, you didn't want to confuse your audience – you wanted to establish one first. He was a fantastic tutor, and very staunch in his approach to sculpture.

When I'm working, I do a lot of research. I often ask my ancestors to guide me. I never used to talk about this but working with other indigenous artists – native Americans, native Canadians, Australian Aboriginals – I've been surprised that a lot of them work that way. Then I do some sketches – I like to draw in ink, I like the blackness of ink – or draw straight on to the paper. Even if you have a design in your head you have to make sure the pattern has enough 'arms' to keep it intact. The cut-out spaces are really important. I liken them to the va, the space in between, where other things can happen. I'm moving more into computer-cut acrylic and stainless steel now, and I'm also interested in public works – how objects and architecture work together to create spaces that humans inhabit.

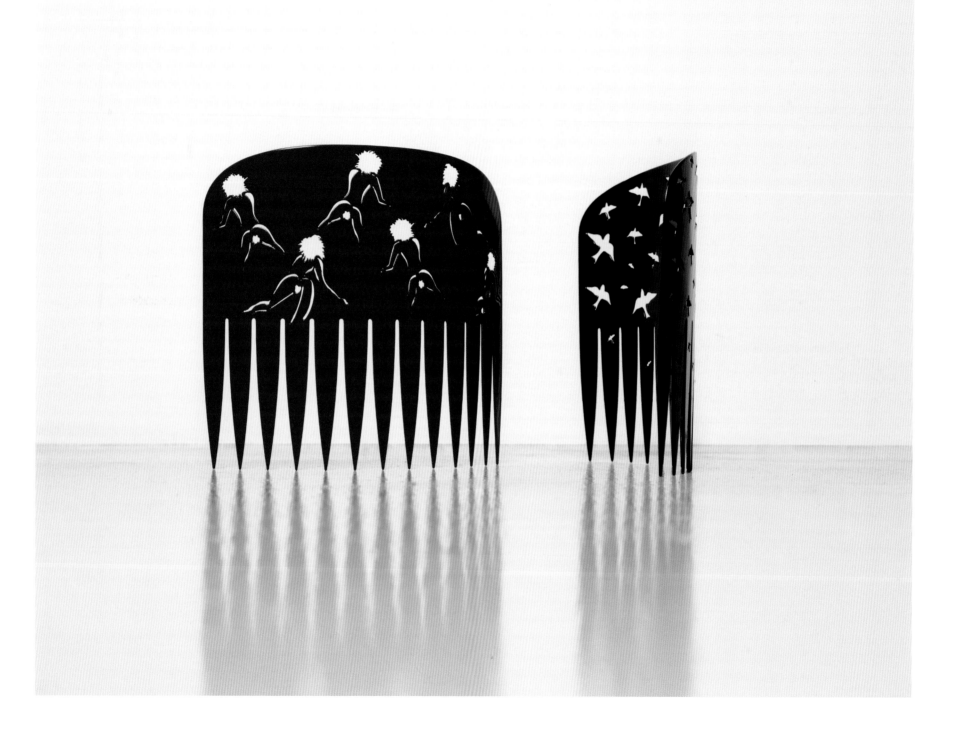

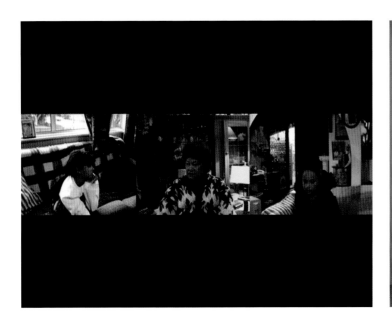

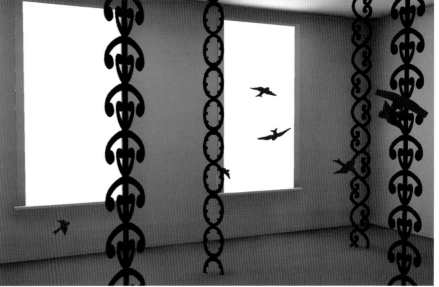

Opposite page:
Bird Girl & Fly Girl, 2009. Two-pot paint on steel, 1100 x 1100 mm each
Collection of the artist [photographer: 'schwerewebber']

This page left to right:
Fish Eyes, 2007. Video (still)
Collection of the artist

Untitled (Garden), 2006. Augmented reality, variable dimensions
Collection of the artist [photographer: Billy Chang]

Joanna Langford

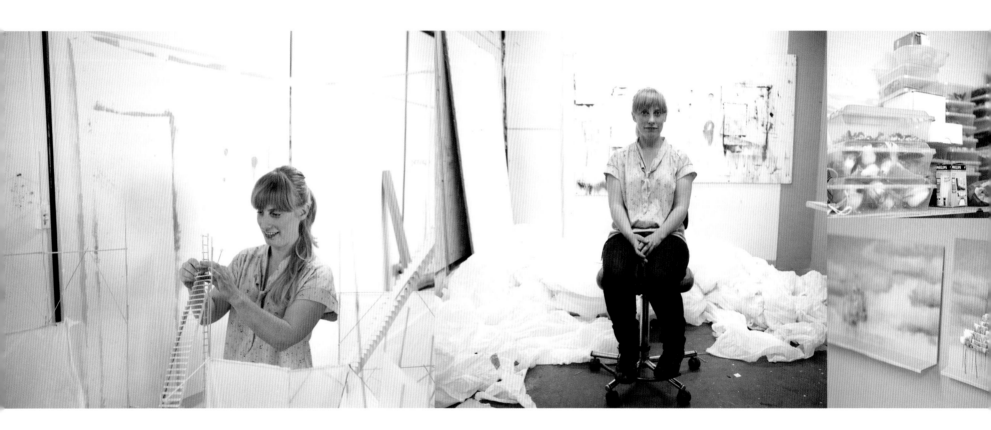

Joanna Langford

My interests stem from the processes and actions of making. A lot of that comes from childhood investigation – making tree huts and working with whatever materials are in the back yard, garage or around the neighbourhood.

Memories of personal adventures and travel are an inspiration for my work. I like the notion of journeying and exploring, especially the romance associated with early epic expeditions, and the stories of rumoured nirvanas such as Timbuktu and El Dorado. I like landscapes that exist in the real but that have a feeling of the fantastic. Like the volcanic landscapes of Rotorua, Cappadocia and Iceland. They feel otherworldly, between reality and a dream.

There is often a sentiment of unease in my landscapes – an unsettled physicality, as if the earth is melting and collapsing. In *Beyond Nowhere* I made a snowy landscape from discarded plastic shopping bags that inflated and deflated. Part of *Down from the Nightlands* was constructed from hundreds of kebab sticks glued together into 13-metre-high towers. These vaulted up towards the ceiling as if to reach out beyond their intended scale, to take on a life of their own.

I work at a recycling centre so I'm always around potential materials. I collect stuff in a womble-like way and store it up until I find a way to adapt it. I usually select materials with an abundant supply, like plastic bags and computer keyboards. I also consider portability and weight. This means that although some of my works are quite big, they seem fragile, non-monumental. I'm conscious of that twisting of scale between the miniature and the expansive toweringness of some of the works.

In some of my earlier works I used confectionery – hundreds and thousands biscuits, wafers and lollies. I liked the textures and the colours and the fact that there was a seemingly limitless supply.

For me, the time between the idea of what I'm going to make and the making of it is really short. This allows for a spontaneous making process, reacting to the materials and the architecture of the space. I use techniques that have been described as 'simultaneous strengthening', where the structures are assessed and strengthened while the construction is in process. In a way I am an anti-engineer designing improbable structures for the real world.

If I have a long installation time I'll make most of the work in situ. If there is only a short time then I prepare in advance by dropping images of the work and the gallery floorplan into Photoshop and create a layout for the space. Some components that are more time-consuming, I'll make in the studio and bring into the gallery like pre-made building blocks.

In the end, my work is often specific to where it's installed. If somebody buys it, I go through a similar process of adapting it to the space. My work is fragile, but I usually encourage the buyer that if something breaks, they can grab a glue gun and fix it.

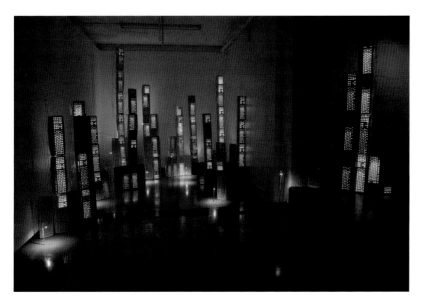

Opposite page:
Baltic Wanderers, 2009. Photograph, 160 x 210 mm
Collection of the artist [photographer: Joanna Langford]

This page left to right:
The Beautiful and the Damned, 2008. Computer keyboards, LED lights & bamboo skewers, variable dimensions
Collection of the artist [photographer: Mark Marriot]

Down from the Nightlands, 2007. Recycled plastic shopping bags, bamboo skewers & 12-volt lights, 13000 x 5000 mm
Collection of the artist [photographer: Richard Wooton]

Julia Morison

Julia Morison

I never made a decision to be an artist. It certainly wasn't encouraged at school. I was Presbyterian and went to a High Anglican school. The church was exotic for me in terms of its décor and little girls dressing up as brides, and I was fascinated. It was a short phase but it made me interested in symbols.

I remember my art teacher setting us a painting project. The title was 'Scarecrow' and I painted an image of the crucified Christ. I was sent to the headmistress and forbidden to use black again. I think that was quite an important turning point for me, when I realised that a powerful image could cause that much upset.

I went on to do design at polytech where the parameters were very tight. I remember one tutor talking for hours on the letter B – how it was constructed, how it came from the cuneiform, how to analyse it geometrically. It was incredibly intense. Though I did well in design – I'm still interested in design – I was consistently getting zero for painting. I thought, what is this mysterious thing I can't do? So I came to Ilam to find out what painting was all about. Then I got hooked; now I'm addicted.

Art school was much more self-directed. I was interested in surrealism, formalism, symbolism – pretty much what I'm still doing, but now it's more integrated. I had this idea that I could build up a system of symbols, using structures already known, like a filing system for organising things, encapsulating everything: psychological and physical, macrocosmic and microcosmic. I was particularly interested in pre-Christian symbols. When I went to France, for the Moët & Chandon Fellowship, I had planned what I was going to do, based on a collection of retablos, Russian icons. The best thing about residencies is the affirmation from your peer group. It also gives you the means to operate on a scale that you might not otherwise be able to – in all those situations I've done large projects.

The work I'm doing now, *Myriorama*, is like a two-dimensional modular Lego system. It can be intimate but also a spectacle; I can do something for a domestic space or a public installation – the pieces can be constantly reconfigured. In essence, it's one work and I think I've always been striving for that one work. I used to think I'd make the perfect painting then die content, but there's no such thing as the perfect painting. Now I just enjoy making stuff. It's a process where I don't want an end. I'm interested in responding to new situations and using different media. This work, when the art is curling around, snake-like, reminds me of the paintings I did as a child – a surreal, animalistic thing. You do go back, but I don't think I'm trying to make so much sense any more. The work's more playful. I think I've lightened up … seriously.

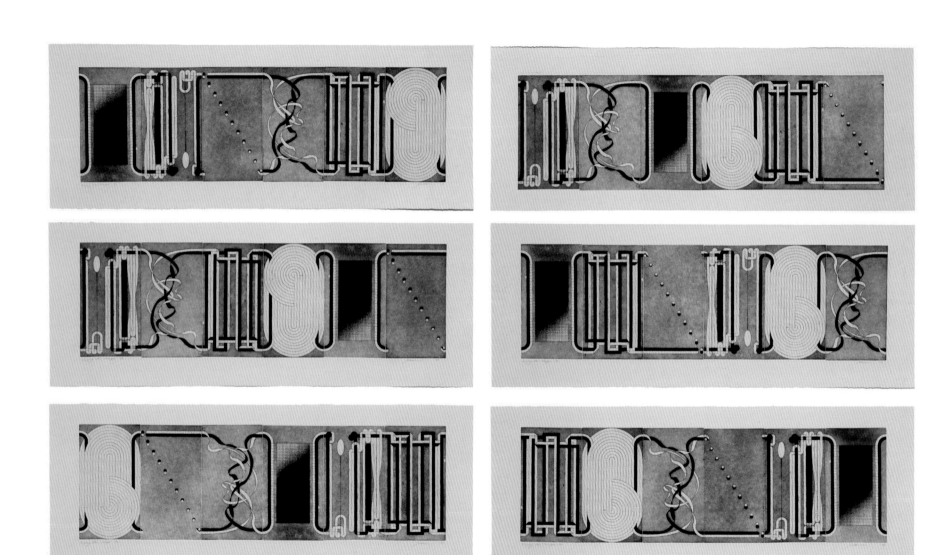

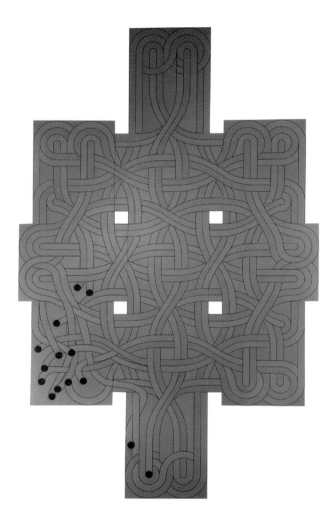

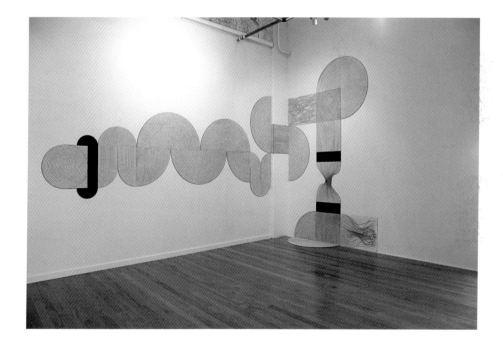

Opposite page:
Ringing the Changes, 2008. Etching, variable dimensions
Collection of the artist

This page left to right:
Looney, 2006. Mixed media on aluminium laminate, 3400 x 2200 mm
Collection of the artist [photographer: Brendan Lee]

Myriorama, 2008. Mixed media on aluminium laminate, variable dimensions
Collection of the artist [photographer: Aisha Roberts]

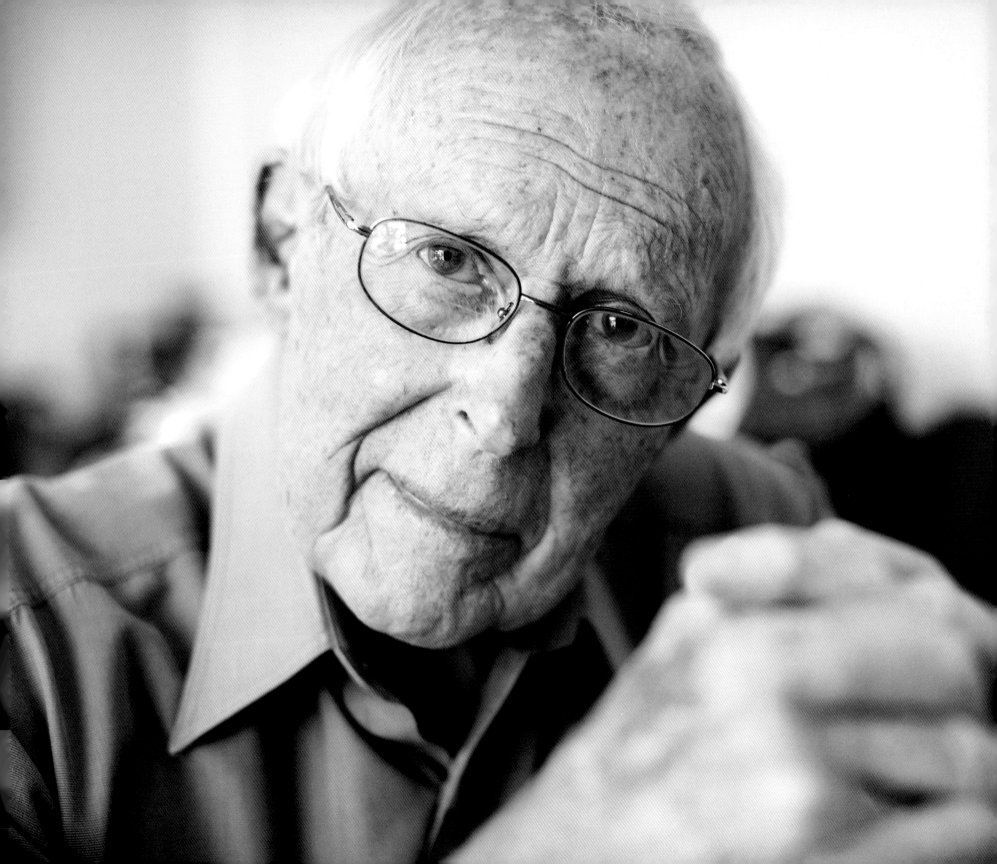

Don Peebles

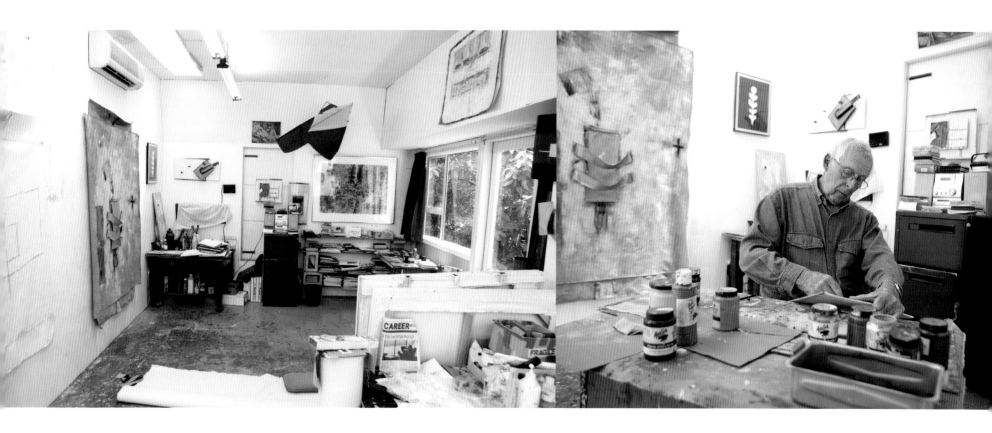

Don Peebles

When I came back to New Zealand, after art school, I decided I was going to do some paintings that contained the things I was interested in, and eradicate from them anything I believed to be a contradiction of my intentions as an artist. I had plenty of examples to help me. In Australia I was introduced to the work of Cézanne, Picasso, the Cubists. In England there was Roger Hilton – he was a brilliant painter, and Victor Pasmore. But it took me about eight years to actually achieve what one might call a pure abstract painting with no references to outside, identifiable elements. That was a hard-fought period in which I was trying to create my own vision and ways of constructing things. In the '70s I did many 3D relief constructions but I wasn't fully satisfied. They were too perfect, too correct. Life's not like that – the system's more rickety than suggested in a true constructivist work. Much as I admire even Mondrian, I'd hate to live in a world designed by him.

People don't believe me when I say this but I do find abstract painting more difficult than representational painting. I remember trying when young to do paintings in a Matisse way. I thought, it doesn't look too difficult – I never succeeded in doing one. They were just too subtle. I realised this wasn't an easy way out. With representational painting you have guides. If I was to paint a portrait, I know if I put a head shape up there, that's acceptable; if I put a hand shape down here, that's acceptable. With abstract painting there's nothing you can draw on. In the end you begin to draw on the ways and the vision that you have developed. What I find is that you often approach a raw canvas with some sort of idea, and you've done drawings supporting that idea. But your painting will never be finished until it has got rid of any semblance of that original idea. You work right through it and you realise that good ideas don't necessarily make good paintings. What looks great in a small drawing can look vacuous and bland in a big work. Now I find myself more involved with the abstract structure of art – an almost visual alphabet of colour, shape and texture – than its actual surface appearance.

I can't stand this wispy sort of comment – oh, how lovely to be artistic. I'm not an artist in that sense. It's nothing to do with that. I'm involved in ideas, their realisation is through visual form – but I am what all people are, ultimately: an organiser. You might organise a business and be more imaginative and creative in that business than I am as a painter. Imagination, daring – all these things that are necessary to create a successful business are the same things you are dealing with in art. I can see, sometimes, some beauty in my painting but it's a beauty that comes from the organisation of one's sense of form. It follows itself. It evolves through its own needs. The paint or whatever you're using talks back to the artist. You listen – it's a two-way process – you're not a dictator.

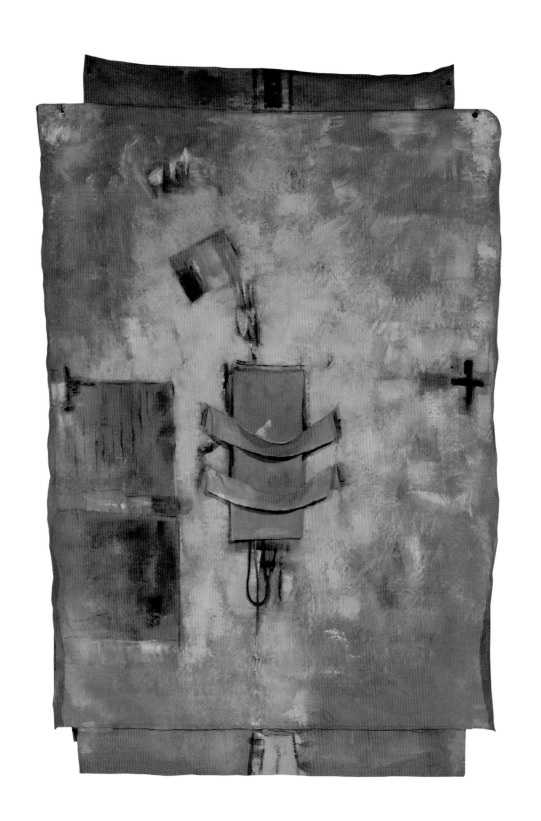

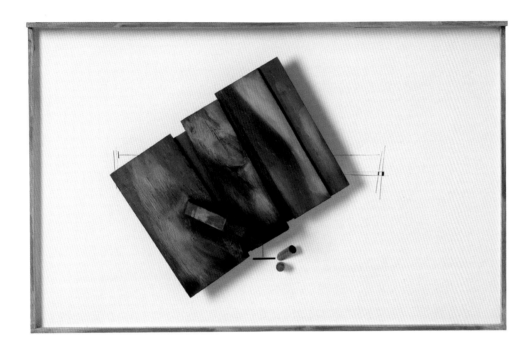

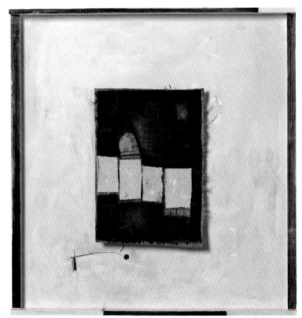

Opposite page:
Painting, 2008. Acrylic, charcoal & rope on linen, 2120 x 1440 mm
Collection of the artist

This page left to right:
Relief – blue in white space, 1997. Acrylic & pencil on wood, 625 x 995 mm
Collection of the artist

Without Title, 2008. Acrylic & mixed media on wood, 593 x 585 mm
Collection of the artist

Séraphine Pick

Séraphine Pick

I find it interesting how stories and mythologies develop around art. Even in my early drawings people made associations with objects; they'd look at an image and say that it reminded them of something they had as a child and then that whole childhood and memory thing came out. That's the line I often get. I don't conceptually work things out beforehand. When I'm painting I start with a feeling then work things out on the painting and this whole idea or story comes out – the painting gathers a life of its own. I like that natural growth of ideas. I know a lot of people wouldn't trust that process. It isn't easy, but I've done it for a long time and it's become the way I work. It's a more organic way of painting. I put a figure in and then some objects, so you have all these odd contrasts going on. It creates the unknown in a way, and that unknown causes unease, when people aren't sure what they are seeing or they don't understand something. Then you're open to all sorts of ways of looking. I don't try and control how people feel but I am interested in the power of images, how images are constructed and how with some work you can be attracted aesthetically to it; at the same time it makes you feel uneasy. Abject art works like that – it's that love-hate, attract-repel thing – and that's what seems to come out of the work I do. A lot of people say my landscapes are desolate, and that desolate aspect is beginning to come through more in my paintings – they're stages or worlds to put figures in and which create this atmosphere. It's not what's in them, it's what they make you feel in terms of atmosphere – that desolation and beauty – that's important. I like that subtlety, that in-betweenness.

I have been put up as a female artist, and I do present a lot of females in my paintings. A lot of people refer to it as self-portraiture but that's not something I'm doing consciously – there are no specific narratives, it's just about perception and reaction. It's not a diaristic thing, it's not about me – I'm almost detached from it. For me it's the act of painting that's the emotive part. What I'm doing is drawing that emotive response from people, and interpretation comes from that. I like it when people can interpret an artwork their own way – it lives and endures that way. Everyone brings their own experience to the work and it is perceived according to that experience. I take the risk to be explorative – sometimes it works and sometimes it doesn't, but at least I'm doing what I feel like doing at the time. There is a lot of pressure to put New Zealandness in paintings but a lot of identity is drawn from history and I don't paint about history. It's more of a universal personal history – it's a quite different approach. It's more human, more intuitive.

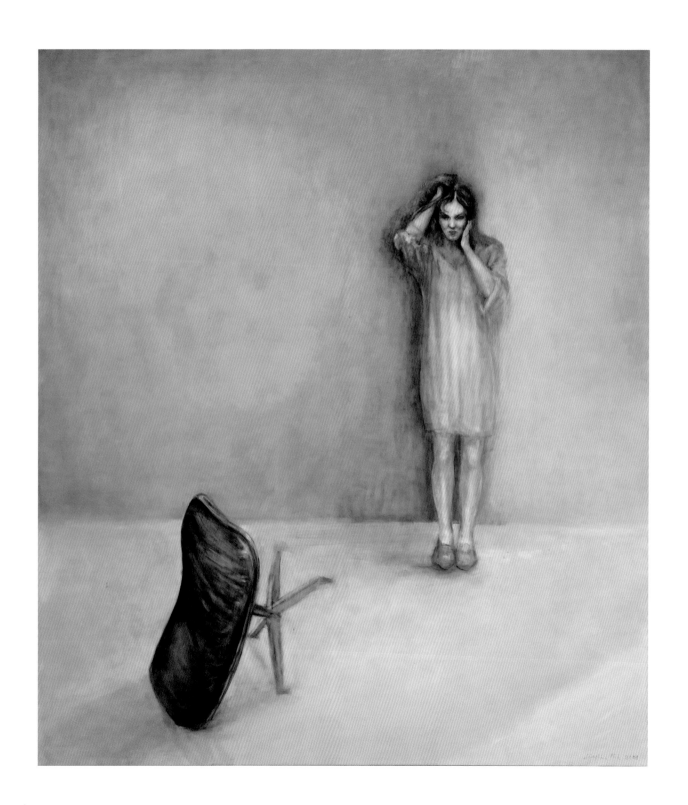

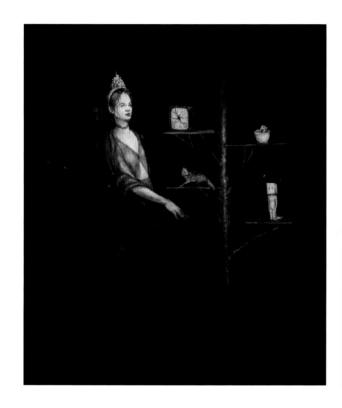

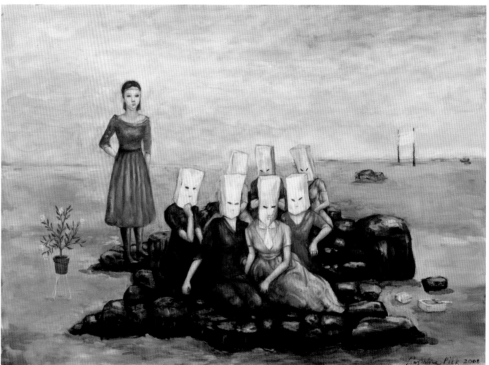

Opposite page:
Surface Paradise, 2008. Oil on linen, 1540 x 1360 mm
Collection of the artist [photographer: Séraphine Pick]

This page left to right:
Wolf-Tree, 2008. Oil on linen, 1070 x 910 mm
Collection of the artist [image courtesy of the artist and Michael Lett, Auckland]

Good Morning, Morning, 2008. Oil on canvas, 1100 x 1250 mm
Private collection [image courtesy of the artist and Michael Lett, Auckland]

Phil Price

Phil Price

After art school a lot of my contemporaries began developing art careers, in painting mostly, but my work was always about objects. I was drawn to the idea of real rather than pictorial space and I definitely wasn't into trying to make sense of who or where we are, or what mistakes we'd made in the past. I'm interested in the conceptual but I also believe art must provide an experience that somehow blows you away. I became besotted by the work of George Rickey. I was mesmerised. I had a good understanding of mechanics, but his stuff transcended simple rotational or reciprocating movement. His best sculptures became something else, more than the sum of their parts, which to me is the criterion for a powerful artwork. I'm not interested in motors, electronic touchpads or sensors. Aesthetically, I don't want my works to look like machines. Rather it's all about the laws of physics, with form and structural influences from the natural world. Balance is the key to this kind of movement. If you take a wheel spinning around the axle – well, that's a bit boring – but if you then spin the axle as well you have two types of movement.

For me that kind of work has a sense of impossibility to it, and I like the idea of arriving at that sense of impossibility through elegant aesthetic and engineering solutions. That usually revolves around the materials and processes I use. I like carbon fibre as it's fantastically strong and light; it also allows the most extraordinary forms to be realised. I love the idea of putting forms together that have a mechanical junction that appears seamless. When you make forms that are organic but abstract it's impossible *not* to relate them to figures. I like various references, but I'm more interested in making sculptures that investigate and manipulate form through movement.

Early on I was influenced by plastic – it has that smooth, fun, confectionery kind of feel to it. Now I'm enjoying more refined processes and elegantly proportioned forms. There are some fabulous contributions from the environment in outdoor sculpture – the way light works, changes in the sky, and those silver, silver days – I'm using a lot of mute silvers and metallics now.

To maintain a presence in New Zealand and Australia, artists often end up dancing to several tunes. That's hard, as the most respected artists are usually those who have developed a singular voice. I have tried to do one thing well. It's interesting that Michelangelo thought the whole carving thing was torturous, yet he was driven to do it. He made David when he was 25 – he chose a piece of stone that no one wanted and made a bigger sculpture than anyone said was a good idea. What an impressive, self-believing thing to do. I think if there's any sort of New Zealand voice in my work, it's not that the moas are dead or anything like that. It's that succeeding-in-the-face-of-adversity kind of approach. No one is going to come along and say we're going to make it easy for you.

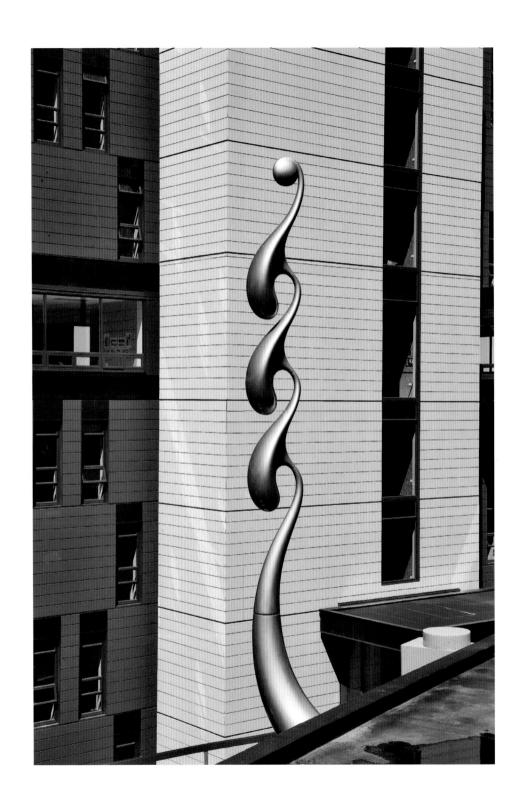

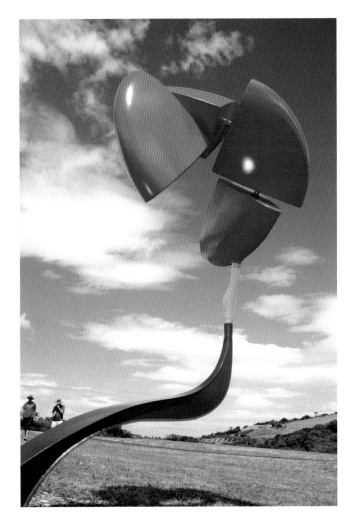

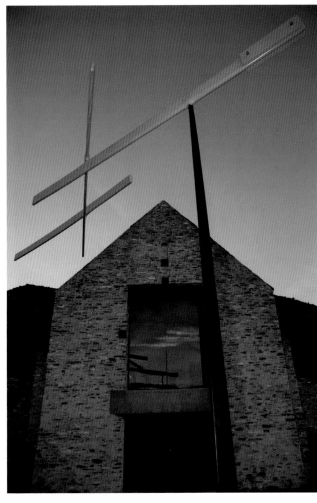

Opposite page:
Organism, 2009. Carbon and glass fibres, high-temperature epoxy, steel & live element bearings, 5000 x 3000 x 3000 mm
Te Puni village campus, Collection of Victoria University, Wellington

This page left to right:
United Divided, 2008. Carbon and glass fibres, high-temperature epoxy, various metals & live element bearings, 3000 x 3000 x 3000 mm
Artist's proof as exhibited in Fucrum, Cable Bay vineyard, Waiheke Island, January 2008 [photographer: Shaun Waugh]

Fulcrum, 2008. Carbon and glass fibres, high-temperature epoxy, steel & live element bearings, 6000 x 6000 x 6000 mm
Artist's proof as exhibited in Fulcrum, Amisfield vineyard, Lake Hayes, April 2008 [photographer: Daz Caulton]

Eion Stevens

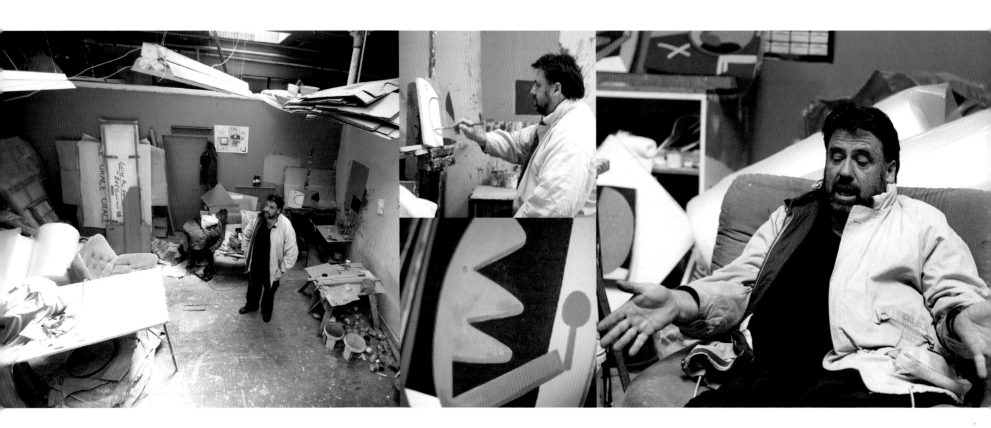

Eion Stevens

Although it's not my own phrase, a 'booby-trap toy' describes an element in my painting practice that has become increasingly important. It is no coincidence that two Australian painters I admire, Sidney Nolan and Charles Blackman, were fans of the French poet Rimbaud. He has a poem where he describes himself as a bird dragging his wing around the ceiling of a room; it's both terrifying and beautiful at the same time. Likewise I loop back through to the old standards: loss, isolation, death, using colour and humour. As an owner of my work once said, 'Eion, your picture stopped being funny and went somewhere else.' Vanity being what it is, I took that as a compliment. I guess I think of my work as manufactured environments, or just little strangenesses – they're slightly unhinged, pretty free-wheeling.

Joan Miro was a revelation when I saw his work 'in person'. Quite disturbing and violently erotic imagery was painted in a 'nine-to-five' manner, which ultimately made them more intense. I have been influenced by this dichotomy between emotion and the means of expression. There are certain images I come back to over and over again, like the Pac-Man images, and the 'heads on spikes' thing. I remember when I was about 10, coming across a photograph in *Time* magazine of a decapitated Boxer rebel in China. This stayed with me and has its parallels in the shotgun marriage/collage technique that I still use. It's that postmodern idea of assemblage and quoting – I am open about naming, say, Picasso, if he is the source of something. He got it from somebody else – it goes on. The po-faced preciousness of much modern painting annoys me constantly.

A lot of my work involves a slightly nervous attack on middle-class safety – a frequent character from a few years back was called 'Mister Comfort'. As Baxter says, 'arguing whether the corpses were dressed in black or red' doesn't make for a creative life. I say nervous because I come from that family background myself, and I still feel the guilt that middle-class people have when they point the finger.

I like the idea of *an* answer, not *the* answer – sometimes there's no narrative at all. Getting up in the morning and saying, 'Today I'm going to deal with my identity' seems absurd to me; more a recipe for bombast than poetry. I am more likely to find a camel while doodling the outline of a guitar. Likewise, if a landscape needs a gigantic black shape on the horizon, that's all the justification I need. This is probably heresy, but it gets me closer to the thing I love: that is, the craft of painting. No one talks about 'making' pictures any more, so it is an increasingly narrow area to work in.

To paraphrase Clive James, being an overnight success took longer than I expected.

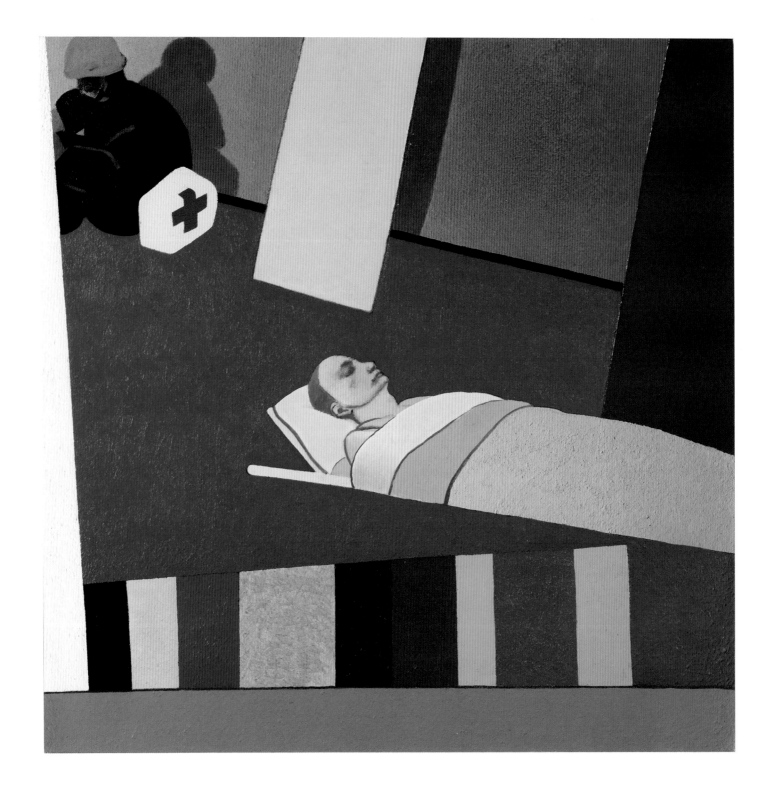

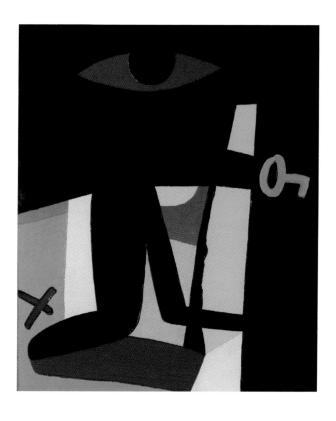

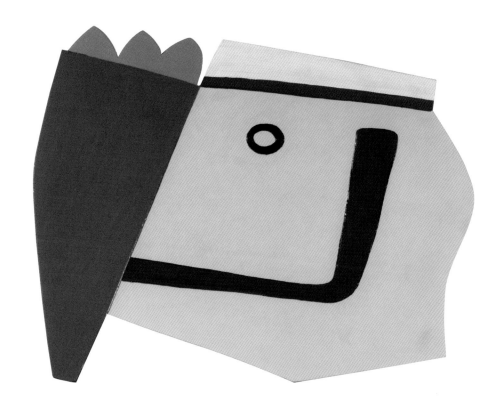

Opposite page:
Frontline, 1982–1986. Oil on prepared board, 1200 x 1200 mm
Collection of the artist

This page left to right:
Key, 2005. Oil on prepared board, 540 x 450 mm
Collection of the artist [photographer: Tjalling de Vries]

Bouquet, 2006. Oil on shaped mdf board, 440 x 610 mm
Collection of the artist [photographer: Tjalling de Vries]

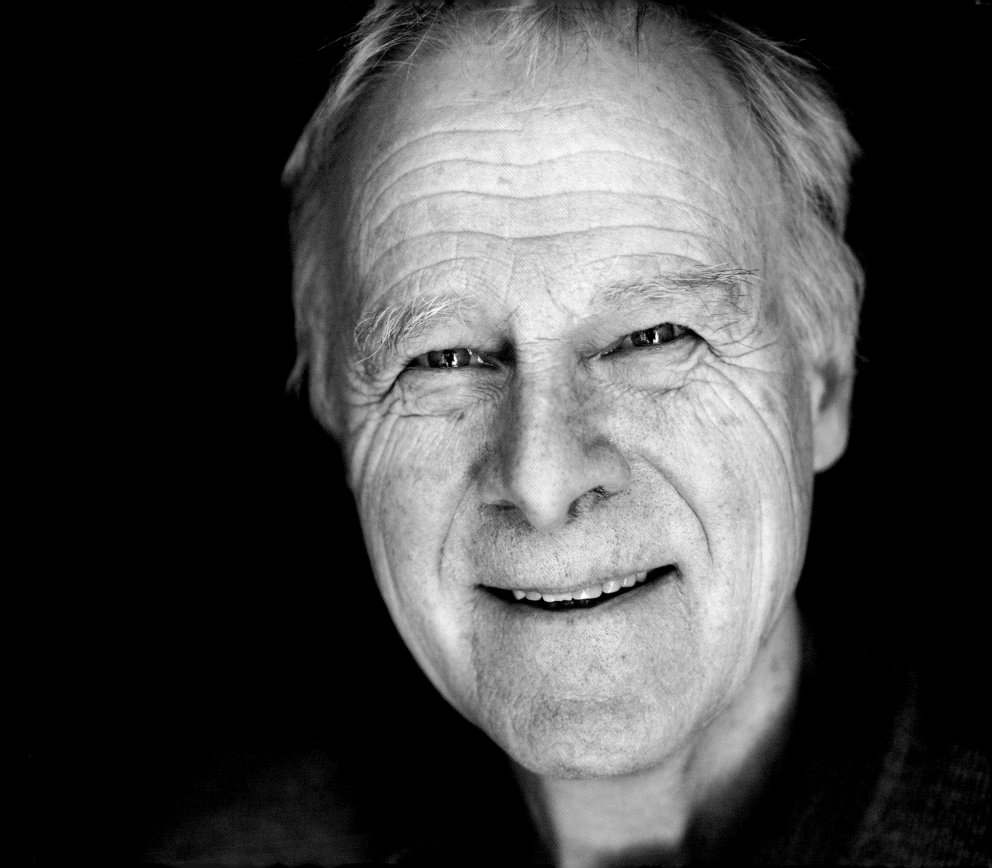

Philip Trusttum

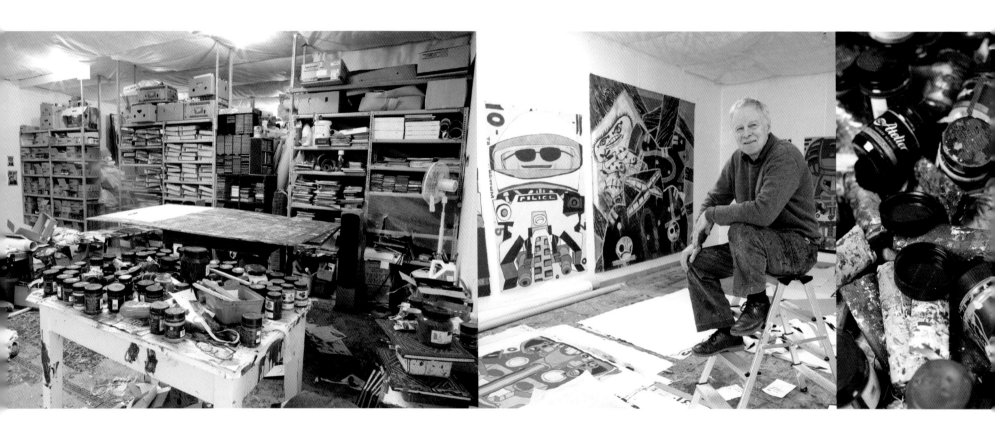

Philip Trusttum

At art school I was looking at Picasso, Pollock, van Gogh, Rothko, Klee – well, everybody really – but it was all to do with colour; colour could speak for itself then. We're getting a lot of art now that's equivalent to Victorian art, that's telling a story, whereas in my work it's the painting, and the quality of the paint, that speak. I think it doesn't actually matter what an artist paints, so long as he or she knows how to do it. In the end 'good' or 'bad' have nothing to do with it. I do all these drawings – I do hundreds of drawings – then I translate them, without looking at them. I have them in my head, and I've learned my A B C D. It's like having all your words: imagine if you had to go to a dictionary for every word you were writing – it'd take you a year to write a page. My drawings are my A B C D. There's a phrase from Samuel Butler: 'Sometimes things are just what is, and not what people want them to be', and as students we were always told that for a painting the reason is an adjunct, it's not enough in itself. Nowadays there's a lot of philosophising – too much, I think.

I remember going to see a Matisse at the Royal Academy. I went there every day and I was listening to people talking – they read so much into it, all these different ideas! I was coming from a completely different angle. I wanted to see what he'd done, how he'd done it, what he'd changed and why. Like McCahon's *I AM* – why did he run the A into the M at the finish? And did he paint over that AM bit at the beginning first, knowing it would show through? But people read art quite differently. Duchamp's right – you do the work, then people read all sorts of things into it. I'm pretty lost about how people view my work. I remember once someone said I was not a New Zealand artist. I was gobsmacked. I think my work epitomises New Zealand by the fact that I am here and by the way I do it – with rolled-up canvases and the rather cavalier attitude I have to my work.

When I was living in Waimate, the work on the farm generated ideas for paintings. There was that change of culture from the city to the farm, and keeping up an eight-acre place is hard work. It was very physical; in town you don't have that physical thing. But often I'd be awake at three in the morning thinking, how can I use all of this? Horse riding, gardening, picking up manure, planting, the weather – I'd incorporate everything.

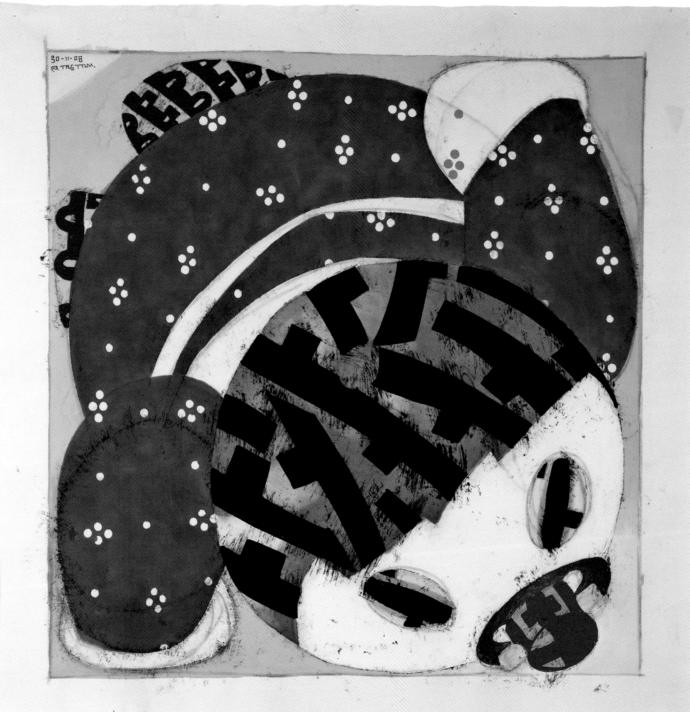

Opposite page:
Odette, 2009. Acrylic on canvas, 1500 x 1500 mm
Collection of the artist

This page left to right:
Money, 2008. Pen & brush, each 125 x 142 mm
Collection of the artist [photographer: Aaron Beehre]

Nails for the Crucifixion, 1 & 2, 2008. Stephens Vivid permanent waterproof marker, 1260 x 297 mm and 1188 x 420 mm
Collection of the artist [photographer: Aaron Beehre]

Ronnie van Hout

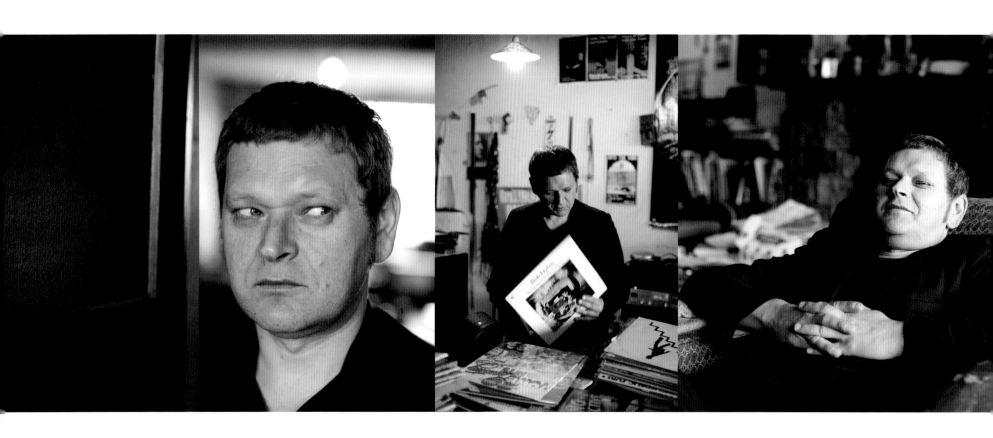

Ronnie van Hout

At high school I was like many people – I thought modern art was unfathomable and a complete mystery. Then there was this one moment when it all made sense, when I understood that art wasn't about realism, but about ideas. That's when I became hooked. I had an interest in film so that's how I ended up at art school. I found film theory to be exciting and contemporary. At that time there was a feeling that you couldn't take part in the world. Art history seemed to be about masterpieces and geniuses – you felt there was no room for you. It seemed that everything, including art, had become corporate. Consequently, a movement of independence and do-it-for-yourself emerged. The music scene I followed was similar. Into the Void (the band I am involved with) was just some friends jamming on Saturday nights. We didn't take it that seriously. We were individually involved in visual art but together we certainly weren't making 'art music'.

Duchamp said, 'There is no solution because there is no problem.' You can never work anything out – it just gets more complex. I used to think art was about expressing yourself – there was that idea of uncovering the unconscious self and showing it to the world. But the idea of the self has changed; it now seems unstable in its relationship to the world, and we are how the world sees us. Art with images of yourself in it is seen as about identity, but my work isn't about identity. Some of my figures have used masks and wigs, but they're not disguises; I'm not trying to hide anything – they're just materials. Like many artists I'm interested in the object-image idea, and I have an interest in acting – what is it? and what is represented? There is a strangeness to acting or performing, where I think both actor and audience safely test their faith in reality. A complicated need that can never be explained fully.

Some people ask what my work is all about, but there's no satisfying answer. I can only lamely ask, what do you think it's about? Any response is as good as any other. There's no meaning. We think art tells us something about ourselves but art can only tell us about our connections to images. I've been fascinated in alien/UFO mythology – what part of ourselves does that come from? The idea of being abducted by aliens – who could make this stuff up? I think the brain can be 'fooled' when it needs certain things to happen. It's like this idea of reproduction – when you make a copy of something and it's an exact copy, is it the same as the original thing? Can it give you the same kind of feelings or memories? People still believe we can talk about contemporary art the way we used to but I think we need to get away from talking about it in terms of something that is necessarily positive; we need a more general discussion about images in society.

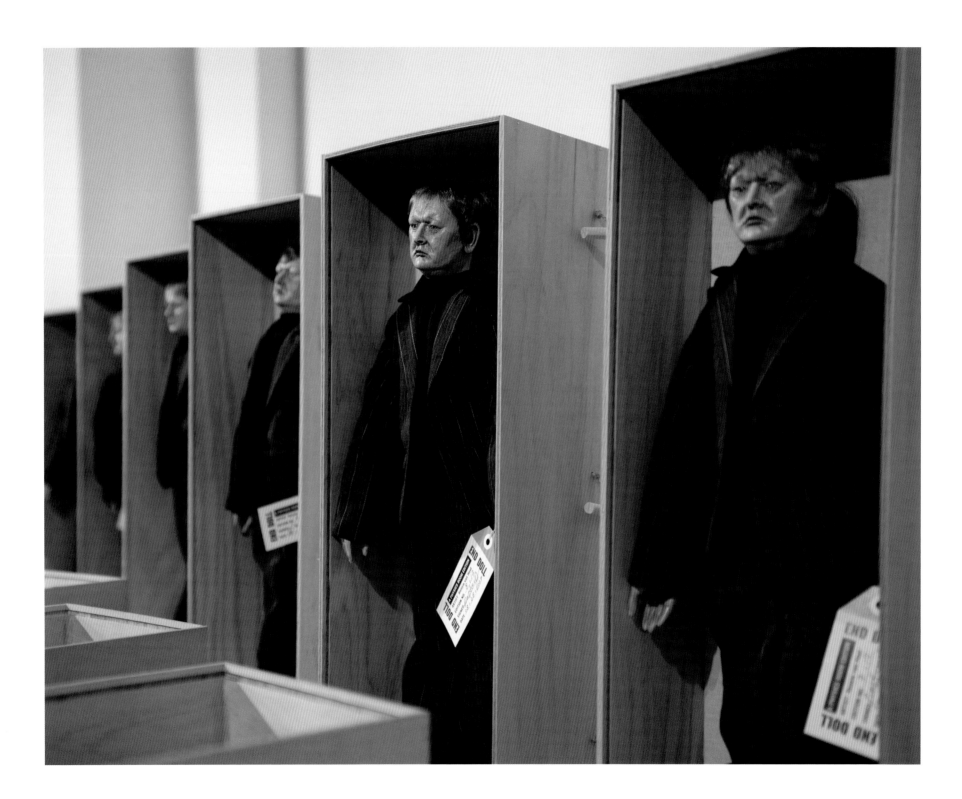

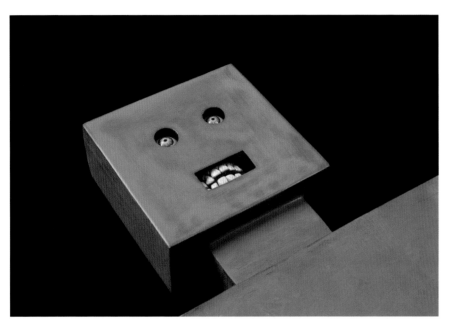 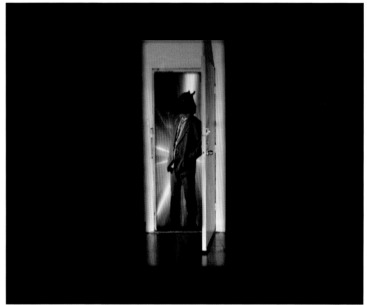

Opposite page:
End Doll, 2007. Mixed media, 550 x 200 x 100 mm
Produced as an edition of 12 for The Physics Room, Christchurch. Various owners [photographer: Mark Gore, courtesy of The Physics Room]

This page left to right:
Failed Robot, 2007. Polystyrene, fibreglass & paint, 1090 x 450 x 175 mm
Private collection, Melbourne [photographer: Vicki Petherbridge]

Unempathy Horse, 2008. Video (still)
Collection of the artist

Artist Information

Hannah and Aaron Beehre

Born 1977, Rotorua (Hannah)
Born 1975, Whangarei (Aaron)
Live in Lyttelton

Hannah and Aaron Beehre have been working together for more than 10 years. Bringing together a fine arts background and a commercial design practice, the couple have shown in a number of galleries and festivals in New Zealand and overseas. Hannah Beehre gained a Bachelor of Fine Arts from the University of Canterbury in 2000 and was granted a year-long residency by the Olivia Spencer Bower Foundation (2004). Aaron is currently lecturing at the School of Fine Arts, University of Canterbury, while completing an MFA. Hannah and Aaron are represented by Jonathan Smart Gallery, Christchurch (NZ); Ryan Renshaw Gallery, Brisbane (Aus).

Selected Exhibitions
2009 *Hannah and Aaron Beehre*, Ryan Renshaw Gallery, Brisbane
JS.02.03 'The Hedge', Christchurch Art Gallery
Snare/Mahanga, Robert McDougall Art Gallery, Christchurch
2008 *Avon Lights*, SCAPE Biennial, Christchurch
Hannah and Aaron Beehre, Vavasour Godkin Gallery, Auckland
2007 *Winter Rose*, Christchurch Arts Festival
JS.02.03, Jonathan Smart Gallery, Christchurch
Art School 125, Christchurch Art Gallery
In Limbo, Vavasour Godkin Gallery, Auckland
2006 *Out of Erewhon: New directions in Canterbury art*, Christchurch Art Gallery
Hannah and Aaron Beehre, Vavasour Godkin Gallery, Auckland
2005 *Wuhan Leaves*, Wuhan Conference Centre, Wuhan, China
WCG.09.05, City Gallery, Wellington
SF.11.05, SOFA Gallery, Christchurch
JS.05.05, Jonathan Smart Gallery, Christchurch
2003 *Medienkunst aus Neuseeland im Cityquartier Frankfurter Welle*, Frankfurt, Germany
Toi Te Papa, State of the Nation exhibition, Museum of New Zealand Te Papa Tongawera, Wellington
Living Room, Third Goodman-Suter Contemporary Art Exhibition, Suter Art Gallery, Nelson
JS.12.03, Jonathan Smart Gallery, Christchurch
BLOY.05.03, Blue Oyster Gallery, Dunedin
AKO3, Auckland Arts Festival
2002 *PHY.09.02*, Physics Room, Christchurch
JS.08.02, Jonathan Smart Gallery, Christchurch
2001 *Prospect*, City Gallery, Wellington

Collections
Museum of New Zealand Te Papa Tongawera, Wellington
Christchurch Art Gallery
Fletcher Trust Collection, Auckland
City of Wuhan, China

Barry Cleavin

Born 1939, Dunedin
Lives in Christchurch

Education/Employment
1978–90 Senior Lecturer in Printmaking, University of Canterbury, Christchurch
1972 Studied at the Honolulu Academy of Art with Gabor Peterdi (Professor of Printmaking at Yale University) and James Koga (Master Lithographer), both of whom were crucial to Cleavin's gestation as a printmaker.
1966 Graduated Diploma of Fine Arts with Honours (Painting), University of Canterbury, Christchurch

Awards
2005 Honorary Doctorate of Letters, University of Canterbury, Christchurch
2001 New Zealand Order of Merit (ONZM)
1972 Hawaii Print Award, Honolulu Academy of Fine Art
1972 QEII Arts Council grant
1967 QEII Arts Council grant

Residencies
1990s Artist in Residence at various institutions around New Zealand
1989 Canberra School of Art

1983 Fulbright Fellowship to work and study at the Tamarind Institute, University of New Mexico
1975 Gippsland Institute of Advanced Education, Victoria

Solo Exhibitions
Barry Cleavin has exhibited widely in New Zealand since 1966, including major surveys of his work curated by leading public art galleries in Auckland, Wellington, Christchurch and Dunedin. In Australia, large solo exhibitions have been presented at the GIAE in Victoria and the University of Tasmania School of Art. In 1998 two exhibitions were staged in Japan, in the Sapporo Museum of Modern Art, where he was guest speaker and exhibitor, and in Hokkaido. He also exhibited in Oregon, US, in 2003 and at the University of Maine.

International Group Exhibitions
Include Print Biennales and Triennales in more than 20 cities throughout Europe, in the Middle East, Asia, the US and South America. Barry's work is documented in numerous publications and art journals in New Zealand and overseas, including the international *Allgemeines Kunstlerlexikon Art Dictionary*.

Neil Dawson

Born 1948, Christchurch
Lives in Christchurch

Education/Employment
2005 Invited Artist Programme, Antarctica
1984– Full-time sculptor
1975–83 Tutor in 3-Dimensional Design and Drawing, Christchurch Polytechnic
Graduate Diploma in Sculpture, Victorian College of the Arts, Melbourne
1971 Diploma of Teaching, Christchurch College of Education
1970 Diploma of Fine Arts (Hons), University of Canterbury, Christchurch

Selected Solo Exhibitions
2007 *Vanishing Points*, Anna Bibby Gallery, Auckland
2006 *Old/New/Borrowed/Blue*, Milford Galleries, Dunedin

Recent Work, Jonathan Smart Gallery, Christchurch
Thoughts on Ice, Janne Land Gallery, Wellington
2005 *Craters*, Anna Bibby Gallery, Auckland
Recent Wall Sculptures, Milford Galleries, Dunedin
2004 Wall Sculpture 2004, Jonathan Smart Gallery, Christchurch
2003 New Wall Sculptures, Peter Webb Galleries, Auckland
Wall Sculptures, Janne Land Gallery, Wellington
2002 *Domes*, City Art, Christchurch
1994 *Steps and Stages*, Jonathan Jensen Gallery, Christchurch
1992 Installation/Exhibition, Luba Bilu Gallery, Melbourne
Infomuse Gallery, Tokyo
1991 New Work, Sue Crockford Gallery, Auckland;
Jonathan Jensen Gallery, Christchurch
1989 *Neil Dawson Site Works 1981–89*, National Art Gallery, Wellington
1988 Wall Sculptures, Roslyn Oxley9 Gallery, Sydney
1987 Wall Sculptures, Sue Crockford Gallery, Auckland
Site Related Work 1981–87, Centre for Contemporary Art, Hamilton
1986 *Overhead Hardware*, Brooke/Gifford Gallery, Christchurch
1985 *Mirrors*, Bosshard Gallery, Dunedin
New Wall Works, Denis Cohn Gallery, Auckland
1984 *Sunset Constructions*, Denis Cohn Gallery, Auckland
Rock Constructions, Brooke/Gifford Gallery, Christchurch
1982 *Land Escapes*, Denis Cohn Gallery, Auckland
1981 *Here and There*, Denis Cohn Gallery, Auckland
Escapes, Peter McLeavey Gallery, Wellington
Boundaries, Brooke/Gifford Gallery, Christchurch
1980 *Here and There*, New Zealand Chancery, Washington DC
1979 *Interiors*, Elva Bett Gallery, Wellington
Order/Chaos, Bosshard Gallery, Dunedin
1978 *House Alterations*, Brooke/Gifford Gallery, Christchurch
1975 *3 Black Holes*, CSA Gallery, Christchurch
Interview Installation, Pinacotheca Gallery, Melbourne
1972 *3 Works*, Pinacotheca Gallery, Melbourne

Selected Group Exhibitions
2006 *Tribute*, Auckland City Art Gallery
2003 *Sculpture on the Gulf*, Waiheke Island
1995 *H2O*, Dowse Art Museum, Lower Hutt
1994 *Incident, Art Now*, Museum of New Zealand Te Papa Tongawera, Wellington
1989 *Magiciens de la Terre*, Musée National d'Art Moderne, Centre Georges Pompidou, Paris
1988 *NZ XI*, Auckland Art Gallery
From the Southern Cross: A view of world art, Sydney Biennale, Art Gallery of NSW
1986 *Content /Context*, National Art Gallery, Wellington
1985 *Six New Zealand Artists: Perspecta '85*, Mori Gallery, Sydney

1980 *4 New Zealand Sculptors*, Sarjeant Gallery, Wanganui
1978 *Platforms*, CSA Gallery, Christchurch
Seventh Mildura Sculpture Triennial, Mildura Arts Centre
1974 *Environmental Structures*, Christchurch Arts Festival

Selected Installations and Commissions
2006 *Anchor*, Victoria Point, Docklands, Melbourne
Wellsphere, Gouldon Square, Rochdale Road, Manchester, England
2005 *Bomber Command Memorial*, Australian War Memorial, Canberra
Raindrops, Lumiere Building, Manchester, England
2004 *Fanfare*, Sydney Harbour Bridge
2003 *Chevron*, Kate Edger Commons, University of Auckland
2002 *Suntrap*, Hastings District Council
Diamonds, National Gallery of Australia, Canberra
Other People's Houses, private commission, Waiheke Island
2001 *Flying Steps*, Hunter Courtyard, Victoria University of Wellington
Cones, Dunedin Public Art Gallery
Chalice, Cathedral Square, Christchurch
2000 *Skies*, West Main Entry Artwork, Stadium Australia, Sydney
1999 *Feathers*, East Main Entry Artwork, Stadium Australia, Sydney
1998 *Ferns*, Civic Square, Wellington
Plumage, Phileo Damansara, Kuala Lumpur, Malaysia
Butterflies, Phileo Avenue, Kuala Lumpur, Malaysia
Tranquility, Tsing Yi MTR Station, Hong Kong
Flora, private commission, Governors Bay, Christchurch
1997 *Vanishing Stairs*, Phileo Promenade, Kuala Lumpur, Malaysia
Leafsphere, Wisma Perkasa, Kuala Lumpur, Malaysia
1996 *Decoy Feathersphere*, private commission, Te Horo
Decoy Down, private commission, Te Horo
Majestic Earth, Majestic Centre, Wellington
1994 *Steps*, Museum of Contemporary Art, Sydney
Nor'West Arch, Lincoln University, Canterbury
Kahu, Takahanga Marae, Kaikoura
Horizons, private commission, Kaukapakapa
Different Skies, Osaka Business Park, Japan
Globe, National Gallery of Australia, Canberra
1993 *Flying Chairs*, Sculpture in the Gardens, Christchurch
Canopy, Queensland Art Gallery, Brisbane
1992 *Snap*, Adelaide Festival Centre
Wave Screens, private commission, Auckland
Throwback, Albert Park, Auckland
Echo (re-installation), Arts Centre, Christchurch
Vertigo, Gallery Kobayashi, Tokyo
1991 *Orb*, private commission, Taranaki

Jetset Globe, Jetset Tours Building, Melbourne
Spectra, Aotea Centre, Auckland
1990 *Globe Down Under*, Sarjeant Gallery, Wanganui
Featherlight, Aotea Centre Foyer, Auckland
1989 *Globe*, Magiciens de la Terre: Musée National d'Art Moderne, Centre Georges Pompidou, Paris
Framework, National Art Gallery, Wellington
Get the Picture, Wellington Railway Station
1988 *Vanity 1*, Biennale, Art Gallery of NSW, Sydney
Vanity 2, Melbourne Concert Hall
1987 *Ripples*, Waikato Museum of Art and History, Hamilton
1986 *Going for Broke: Sculpture Projects 1985–86*, Govett-Brewster Art Gallery, New Plymouth
1984 *The Rock*, BNZ Centre, Wellington
5 Large Works, Graduate Centre Mall, City University, New York
Lightwell, private commission, Wellington
1981 *Echo*, Arts Centre, Christchurch
Vanishing Points, Auckland City Art Gallery
Reflections, National Art Gallery, Wellington
1980 *Street Show: Street Grid*, Robert McDougall Art Gallery, Christchurch
Seascape Installation/Documentation, Robert McDougall Art Gallery, Christchurch

Awards
2004 Companion of the New Zealand Order of Merit
2003 Laureate Award, New Zealand Arts Foundation
1985 QEII Arts Council grant (establishment)
1980 QEII Arts Council grant (travel)
1972 QEII Arts Council grant

Tony de Lautour

Born 1965, Melbourne
Lives in Christchurch

Education
1988 Graduated Bachelor of Fine Arts (Sculpture), University of Canterbury, Christchurch

Solo Exhibitions
2009 *B-Sides and Demos*, Physics Room, Christchurch
Revisionist Paintings and New Ceramics, Ivan Anthony Gallery, Auckland
2008 *Souvenirs*, Hamish McKay Gallery, Wellington
Text Message, Brett McDowell Gallery, Dunedin; Brooke/Gifford Gallery, Christchurch
Paintings, Ceramics, Prints, Ray Hughes Gallery, Sydney
2007 *Trance*, Hamish McKay Gallery, Wellington
2006 *Silent Command*, Brooke/Gifford Gallery, Christchurch

Woodcuts and Paintings, Ray Hughes Gallery, Sydney
Tony de Lautour, Brett McDowell Gallery, Dunedin
2005 *Underworld*, Hamish McKay Gallery, Wellington
Powder Land, Brooke/Gifford Gallery, Christchurch
2004 *1994–2004*, Hamish McKay Gallery, Wellington
Paintings 1994–2004, SOFA Gallery, Christchurch
Heads, Lions, Snakes, Mountains, Brooke/Gifford Gallery, Christchurch
Paintings & Objects, Ivan Anthony Gallery, Auckland
Paintings, Ray Hughes Gallery, Sydney
2003 *New Paintings & Works on Paper*, Brooke/Gifford Gallery, Christchurch
New Paintings, Hamish McKay Gallery, Wellington
Landscaper: Tony de Lautour recent paintings, Te Manawa, Palmerston North
Landfill, Ivan Anthony Gallery, Auckland
2002 *Revisionist Paintings*, Waikato Museum of Art and History, Hamilton; Govett-Brewster Art Gallery, New Plymouth; City Gallery, Wellington
2001 *Landscapes, Portraits, Plans*, Ivan Anthony Gallery, Auckland
Landscapes and Portraits, Hamish McKay Gallery, Wellington
2000 *New History Paintings*, Hamish McKay Gallery, Wellington; Ivan Anthony Gallery, Auckland
New Paintings, Brooke/Gifford Gallery, Christchurch
1999 *Revisionist Paintings*, Hamish McKay Gallery, Wellington; Ivan Anthony Gallery, Auckland
New History Paintings, Brooke/Gifford Gallery, Christchurch
1998 *The Painted Objects of Tony de Lautour*, Hamish McKay Gallery, Wellington; Ivan Anthony Gallery, Auckland
1997 Anna Bibby Gallery, Auckland; Brooke/Gifford Gallery, Christchurch
100 Paintings and a Large Saw, Hamish McKay Gallery, Wellington
1996 *Southern Monograms*, Lesley Kreisler Gallery, New Plymouth; Hamish McKay Gallery, Wellington
1995 *New White Collection*, Brooke/Gifford Gallery, Christchurch; Claybrook Gallery, Auckland (with Jeff Brown); Hamish McKay Gallery, Wellington (with Jason Greig)
1995 *Two Heads are Less than One*, Brooke/Gifford Gallery, Christchurch (collaboration with Peter Robinson); Volcano Café, Lyttelton
1994 *Bad White Art*, Brooke/Gifford Gallery, Christchurch; Teststrip Gallery, Auckland
1993 *Tony de Lautour*, Claybrook Gallery, Auckland
1992 *Paintings and Drawings*, CSA Gallery, Christchurch
1991 *Paintings and Drawings*, CSA Gallery, Christchurch (with Spencer Hamilton)
1990 *Paintings and Drawings*, CSA Gallery, Christchurch

Selected Group Exhibitions
2007 *Of Deities and Mortals*, Christchurch Art Gallery
2004 *Home Sweet Home: Works from the Peter Fay Collection*, National Gallery of Australia, Canberra
Coming Home in the Dark, Christchurch Art Gallery
2003 *Supernova: A tribute to Giovanni Intra*, Hamish McKay Gallery, Wellington
Bombs Away, Adam Art Gallery, Wellington; Physics Room, Christchurch
5 New Zealand Artists, Ray Hughes Gallery, Sydney
2002 *The Big Bang Theory: Recent Chartwell acquisitions*, Auckland Art Gallery
2001 *Dark Plain*, CoCA Gallery, Christchurch
Prospect 2001: New Art New Zealand, City Gallery, Wellington
Bright Paradise: Exotic history and sublime artifice, 1st Auckland Triennial, Auckland
Te Maunga Taranaki: Views of a mountain, Govett-Brewster Art Gallery, New Plymouth
Alive!: Still life into the 21st century, Adam Art Gallery, Wellington
2000 *Manufacturing Meaning: The Victoria University art collection in context*, Adam Art Gallery, Wellington
Wonderlands: Views on life at the end of the century, at the end of the world, Govett-Brewster Art Gallery, New Plymouth
Old Worlds/New Worlds: Contemporary art from Aotearoa/New Zealand, Art Museum of Missoula, Missoula, Montana; Maui Arts and Cultural Centre, Hawaii
New Art from New Zealand, Ray Hughes Gallery, Sydney
Collection of the Artist, Sarjeant Gallery, Wanganui
Canterbury Paintings in the 1990s, Robert McDougall Art Gallery, Christchurch
1999 *Gruesome!*, McDougall Art Annex, Christchurch
Fiat Lux Fundraiser, Fiat Lux, Auckland
1998 *Earthmovers and Skywriters*, McDougall Art Annex, Christchurch
1995 *Close Quarters: Contemporary art from Australia and New Zealand*, Monash University Gallery and Australian Centre for Contemporary Art, Melbourne; Institute of Modern Art, Brisbane; Canberra School of Arts Gallery, Canberra; Govett-Brewster Art Gallery, New Plymouth; Auckland Art Gallery
1997 *Now Showing: Artists go to the movies*, Film Centre, Wellington (toured)
Aesthetic Departures, CoCA Gallery, Christchurch
Wet Behind the Ears, Teststrip Gallery, Auckland
1996 *Pins and Needles: Eight Christchurch artists*, Suter Art Gallery, Nelson
Fundraising Exhibition, High Street Project, Christchurch
Failure?, Linden Gallery, Melbourne

1995 *A Very Peculiar Practice: Aspects of recent New Zealand painting*, City Gallery, Wellington
Visa Gold Art Award, City Gallery, Wellington
Hangover, Waikato Museum of Art and History, Hamilton; Govett-Brewster Art Gallery, New Plymouth; Dunedin Public Art Gallery; Robert McDougall Art Gallery, Christchurch
Please Give Generously, Teststrip Gallery, Auckland
1994 *Prostrate Canterbury*, High Street Project, Christchurch
Stimulus to Style: The metamorphosis of an artwork, CSA Gallery, Christchurch; Hamish McKay Gallery, Wellington
The Face: Artistic head operations, Govett-Brewster Art Gallery, New Plymouth
1993 *Cartel*, Brooke/Gifford Gallery, Christchurch
Tattoo, High Street Project, Christchurch
Lineage, McDougall Art Annex, Christchurch
Tony de Lautour, Michael Harrison, Jason Greig, Hamish McKay Gallery, Wellington
1992 *Club Coelacanth*, Osaka, Japan.
Canvassing South, Gow Langsford Gallery, Wellington
Vanitas: Aspects of the contemporary still life, McDougall Art Annex, Christchurch
1991 *Sculpture in the Quad*, Christ's College, Christchurch
The Chair Show, CSA Gallery, Christchurch

Awards
1995 Winner, Visa Gold Art Award

Andrew Drummond

Born 1951, Nelson
Lives in Christchurch

Education/Employment
1992–2003 Senior Lecturer in Sculpture, University of Canterbury, Christchurch
1975 BA (Hons) Waterloo, Ontario, Canada

Selected Solo Exhibitions
2008 *From Motion; STILLness*, Page Blackie Gallery, Wellington
2006 *Views of Particles*, Vavasour Godkin Gallery, Auckland
2005 *The Light and Dark of Visibility*, Vavasour Godkin Gallery, Auckland
2002 *Rotating, Assigning, Displacing*, Dunedin Public Art Gallery
Rotating/Revealing, Manawatu Art Gallery, Palmerston North
2000 *Rotating/Revealing*, Jonathan Smart Gallery, Christchurch
1998 *Cascade*, Andrew Jensen Gallery, Auckland
1997 Recent Work, Andrew Jensen Gallery, Wellington

Samples and Speculations, Jonathan Smart Gallery, Christchurch
Recent Work, Gow Langsford Gallery, Auckland
1992 *Between Rocks and Glasshouses* (with architect Noel Lane), City Gallery, Wellington
1990 *Crossroads*, Ipswich Regional Gallery, Townsville
1988 *Agricultural Still Life*, Gow Langsford Gallery, Auckland
Images from the Woodcutter, ArtSpace, Auckland
1987 FiveSights, Vessels and Containers, Braided Rivers, Dunedin Public Art Gallery (toured Wanganui, New Plymouth, Lower Hutt)
1984 *From the Valley of the Shadow*, ASPEX Gallery, Portsmouth, England
1982 *Cycles/Stages* (installation), National Art Gallery, Wellington
1980 *Relics*, Hocken Gallery, Dunedin
1979 *Walking* (video installation), Elva Bett Gallery, Wellington
The Grass is Greener (video installation), Manawatu Art Gallery, Palmerston North
1978 *Tattoo Tapes/Onto Skin*, (video installation), Auckland Art Gallery
1977 *One Night & One Day*, Elva Bett Gallery, Wellington

Selected Group Exhibitions
2008 *Aspects of the Gallery*, Vavasour Godkin Gallery, Auckland
Group Show, Vavasour Godkin Gallery, Auckland
2007 *Fast Forward*, Vavasour Godkin Gallery, Auckland
In Limbo, Vavasour Godkin Gallery, Auckland
2006–07 Group Show, Vavasour Godkin Gallery, Auckland
2005 Group Exhibition, Vavasour Godkin Gallery, Auckland
2004 *Project 04: Contemporary New Zealand Sculpture*, Peter Webb Fine Art Gallery, Auckland
2001 *Dark Plain*, Christchurch Arts Festival, CoCA Gallery, Christchurch
2000 *Counter Rotating Device*, Art and Industry Biennial, Christchurch International Airport
Assignation Device, Royal Sun Alliance Building, Auckland
1999 *Dream Collectors*, Dunedin Public Art Gallery
Artbarns: After Kurt Schwitters (exhibition of 10 international artists in barns), Forest of Bowland, Lancashire, England
1998 *Lights and Shadows*, Dunedin Public Art Gallery
Proscenium, Artspace, Auckland
Action Replay, Artspace, Auckland; Govett-Brewster Art Gallery, New Plymouth
Dream Collectors, Auckland Art Gallery
1997 *Dream Collectors*, Museum of New Zealand Te Papa Tongarewa, Wellington
1994 *Art Now*, Museum of New Zealand Te Papa Tongarewa, Wellington

1992 *Headlands: Thinking through NZ art*, Museum of Contemporary Art, Sydney; Museum of New Zealand Te Papa Tongarewa, Wellington

Residencies
1999 Wycoller, Lancashire, England: Artbarns Project (Lancashire County Council)
1990 Queensland: Queensland Art Gallery, Australia New Zealand Foundation
1987 Wanganui: Sarjeant Gallery
1984 Orkney, Scotland: Pier Arts Centre
Portsmouth, England: ASPEX Gallery
1980 Dunedin: Frances Hodgkins Fellow (University of Otago)

Awards
1999 CNZ grant (Projects Environment commission)
1995 CNZ grant (Robert McDougall Art Gallery commission)
1990 Australia–New Zealand Foundation Fellowship
1981 QEII Arts Council grant

Darryn George (Ngapuhi)

Born 1970, Christchurch
Lives in Christchurch

Education/Employment
1999– Head of Art, Christ's College, Christchurch
1998 Master of Fine Arts (Painting), Royal Melbourne Institute of Technology
1994 Diploma of Teaching, Christchurch College of Education
1993 Bachelor of Fine Arts (Painting), University of Canterbury

Selected Solo Exhibitions
2009 *Whare Pukapuka*, Brooke/Gifford Gallery, Christchurch
2008 *Pukapuka*, Gow Langsford Gallery, Auckland
Pulse, Christchurch Art Gallery
Konei Korero, Peter McLeavey Gallery, Wellington
Pohi, Cable Bay Vineyards, Waiheke Island
2007 *Countdown*, City Gallery, Wellington
Tatau, Brooke/Gifford Gallery, Christchurch
2006 *Marama/Arawhata*, Peter McLeavey Gallery, Wellington
Turanga, Starkwhite, Auckland
Matapihi, Brooke/Gifford Gallery, Christchurch
2005 *From Maui to Moses*, FHE Galleries, Auckland
2004 *Darryn George*, Brooke/Gifford Gallery, Christchurch; Span Galleries, Melbourne; Starkwhite, Auckland

2003 *Stairway to Heaven*, Peter McLeavey Gallery, Wellington
Tipuna, Brooke/Gifford Gallery, Christchurch
2002 *We apoligise, appair we to be having some technically probl be backk soon*, Brooke/Gifford Gallery, Christchurch
2001 *Zoom*, SPAN Galleries, Melbourne
The T.A.T. Show, Peter McLeavey Gallery, Wellington
The Hippy Hop Show, Brooke/Gifford Gallery, Christchurch
2000 *Evisible (with Phil Price)*, Christ's College dining hall, Christchurch
Fastfoward, Brooke/Gifford Gallery, Christchurch
1999 *Written on Tablets*, SPAN Galleries, Melbourne
1998 *Hide and Seek*, Ramp Gallery, Waikato Polytechnic, Hamilton
1994 *Parawhenuamea/Noah*, Dobson Bashford Gallery, Christchurch

Selected Group Exhibitions
2009 Auckland Art Fair, Gow Langsford Gallery stand
2008 *The Stations of the Cross*, Gus Fisher Gallery, Auckland
The Spring Catalogue Show, Gow Langsford Gallery, Auckland
2007 *New Painting in the Digital Age*, Pataka, Porirua; Te Tuhi Centre for the Arts, Auckland
Auckland Art Fair, Gow Langsford Gallery stand
The Spring Catalogue Show, Gow Langsford Gallery, Auckland
Hei Konei Mai: We'll meet again, Auckland Art Gallery
125 Years of the Canterbury School of Fine Arts, Christchurch Art Gallery
Maori Students at Canterbury University, SOFA Gallery, Christchurch
2005 *The Koru Club*, Pataka, Porirua
2004 *Whare*, Tandaya Gallery, Adelaide Festival
Prospect 2004, City Gallery, Wellington; Adam Art Gallery, Wellington
2002 *Up/Down/Up*, Canterbury Museum, Christchurch
Whare, SOFA Gallery, Christchurch
2001 *Techno Maori*, City Gallery, Wellington
2000 *Canterbury Painters in the 1990s*, Robert McDougall Art Gallery, Christchurch
Melbourne Art Fair, Royal Exhibition Hall, Melbourne
1999 *Hiko! New Energies in Maori Art*, McDougall Art Annex, Christchurch
1998 *n.z.*, Gallery 101, Melbourne
Strata, SPAN Galleries, Melbourne
1997 *Nga Matatini Maori*, McDougall Art Annex, Christchurch
1996 *Recent Maori Sculpture*, Govett Brewster Art Gallery, New Plymouth

Awards
2004 Te Waka Toi grant
2000 Finalist in Wallace Art Award
 CNZ funding for Melbourne Art Fair
1998 CNZ grant (Melbourne Project at SPAN Galleries)
1994 Te Waka Toi grant

Lonnie Hutchinson

Born 1963, Auckland
Lives in Auckland

Education/Employment
1999 Diploma of Education, Christchurch College of
 Education
1998 Bachelor of Design (3D), Unitec, Auckland

Solo Exhibitions
2009 *My Mother*, Jonathan Smart Gallery, Christchurch
2008 *Beat the Feet*, Christchurch Cathedral, SCAPE
 Christchurch Biennial
 Fish Eyes, MIC Toi Rerehiko (moving image centre),
 Auckland
2007 *Black As*, Jonathan Smart Gallery, Christchurch
 Paper Scissors Rock, Ramp Gallery, Wintec, Hamilton
 Under the Surface, Infinity Building, Wanaka
 Phantasmagoria, Jonathan Smart Gallery, Christchurch
 Parallel Seductions, City Gallery, Wellington
 Wet Black, City Gallery, Wellington
 Paradise Lust, Mary Newton Gallery, Wellington
 This Show is What I Do, Institute of Modern Art,
 Brisbane
 Red SQUARE2, City Gallery, Wellington
 Black Pearl, Jonathan Smart Gallery, Christchurch
2001 *Catching the Fe'e*, Hastings Exhibitions Centre, Napier
2000 *Coconut Dreams*, SOFA Gallery, Christchurch
1997 *Can You See Me?*, QEII Square, Kartoun Place,
 Auckland
1996 *Cream*, Unitec Performance Space, Auckland

Selected Group Exhibitions
2008 *Foulaga: The past coming forward*, Kaohsiung Museum
 of Fine Arts, Taiwan
 The Blue Room: 13 artists respond in a psychic way, Blue
 Oyster Gallery, Dunedin
 Ngai Tahu 6, Gallery 33, Wanaka
 Art Suitcase Project, Auckland Art Gallery (toured)
 Dateline Returns, Govett-Brewster, New Plymouth
 Contemporary Samoa, Pataka, Porirua
 Dateline: Contemporary art from the Pacific, Kiel City
 Gallery, Kiel, Germany
2007 *Dateline: Contemporary art from the Pacific*, Neuer
 Berliner Kunstverein (NBK), Berlin, Germany

News from Islands, Cambelltown Art Centre, Sydney
Face Value: Video Portraiture from the Pacific, Portrait
Gallery, Wellington
20 Years On, Jonathan Smart Gallery, Christchurch
Picturing the Peninsula, Christchurch Art Gallery
Norsewear Art Award, Hastings Exhibition Centre,
Hastings
Eternal Thread, Christchurch Art Gallery
Le Folauga, Auckland Museum
Restless, Moving Image Centre, Auckland
2006 *First Nations Women's Film Screening from New Zealand
 & Okanagan*, Alternator Gallery, Kelowna, Canada
 Triple Candy, Jonathan Smart Gallery, Christchurch
 Crosscurrents, Judith Anderson Gallery, Hastings
 TransVersa, South Project, Museo de Arte
 Contemporane, Galeria Metropolitana, Santiago, Chile
 Satellite, New Zealand Pavilion, Shanghai, China
 Mo Tatou: Ngai Tahu Whanui, Museum of New
 Zealand Te Papa Tongarewa, Wellington
 Pacifika Styles, Cambridge University, Cambridge,
 England
 This is Not a Love Song, Art Station, Auckland
 Learning from the Knee, Burrinja Gallery, Upwey,
 Melbourne
2005 *Qpacifica*, Griffith University Gallery, Brisbane
 Letters to the Ancestors, Waikato Museum of Art,
 Hamilton
 Eternal Thread, toured Salem, San Francisco
 Destinations, Methodist Church, K-Road Fringe
 Festival, Auckland
 Urban Art from the Pacific, du Chateau de Saint Auvent,
 France
 Presence, Institute of Modern Art, Brisbane
 Face Value: Video portraiture from the Pacific, Ivan
 Dougherty Gallery, Sydney; Museum of Brisbane
 Eternal Thread Toi Maori, Auckland Museum
 Remember New Zealand, Artspace, Auckland
2004 National Drawing Awards, Artspace, Auckland;
 Physics Room, Christchurch
 Permissions, Lane Gallery, Auckland
 The Wallace Art Award Finalist Show, Wallace Trust
 Gallery, Auckland; Dowse Art Museum, Lower Hutt
 Home/Ground, SCAPE Art & Industry Biennial,
 Christchurch Art Gallery
 Nice Coloured Dolls, 24HR Art, Darwin
 Remember New Zealand, São Paulo Biennial, Brazil
 Out of the Dark, WiseART Gallery, Brisbane
 Telecom Prospect 2004, City Gallery, Wellington
 Aotearoa Barbie, CoCA Gallery, Christchurch
 PUBLIC/PRIVATE: Tumata/Tumataiti, 2nd Auckland
 Triennial, Auckland Art Gallery
 The Eternal Thread: Toi Maori, Pataka, Porirua (toured
 Rotorua, Auckland, Adelaide)

IKA, and thanks for the IKA, Artspace, Auckland
2003 *Lost and Found*, Queensland Art Gallery, Brisbane
 Nii'kso'kowa: My blood relative, The Other Gallery,
 Banff Centre, Canada
 IKA, and thanks for the IKA, Contemporary Art Centre,
 Vilnius, Lithuania
 Flaunt, Auckand Art Gallery
 The Loni and Roni Show, Physics Room, Christchurch
 20:20 Sight Spacific, CoCA Gallery, Christchurch
 (toured)
 Sacred Icon ... Soiled Earth, Grantham Galleries,
 Auckland
 Te Puawai o Ngai Tahu, Christchurch Art Gallery
 VaHine, Lane Gallery, Auckland
2002 *Dolly (w)rapper Mix*, Waikato Museum of History and
 Art, Hamilton; Pataka, Porirua
 Whare, Art & Industry Urban Arts Biennial, SOFA
 Gallery, Christchurch
 Cross Currents, Lane Gallery, Auckland
 Ole Malaga, Millenium Public Art Gallery, Blenheim
2001 *Purangiaho: Seeing Clearly*, Auckland Art Gallery
 Tautai, International Sculpture Symposium, Auckland
 Wahine Pacifica, Te Wa: The Space, Wanganui
 Out of the Blue, Napier Museum
2000 *Biennale d'art Contemporain*, Jean-Marie Tjibaou
 Center, Noumea, New Caledonia
 Island Crossings, Global Arts Link, Ipswich, Brisbane
 Measure This, CoCA Gallery, Christchurch
1999 *Hiko! New Energies in Maori Art*, McDougall Art
 Annex, Christchurch

Residencies
2007 *News from Islands*, Cambelltown Art Centre, Sydney
2006 *Transversa*, Museo de Arte Contemporaneo South
 Project, Santiago, Chile
2003 *Communion and other Conversations*, Banff Centre,
 Canada
2000 Macmillan Brown Centre for Pacific Studies,
 University of Canterbury, Christchurch

Awards
2005 HitLab NZ Content Scholarship, University of
 Canterbury
2004 CNZ award (emerging artist)
2003 Centre of Contemporary Art/Guthrie Travel Award

Commissions
2004 University of Auckand
2006 Grey Lynn Public Art Project, Auckland City Council
2008 TV spaceman for TVNZ, Peace Piece, Godley Head,
 Banks Peninsula
2008 *Beat the Feet*, Art & Industry Biennial, Christchurch
 Cathedral

Joanna Langford

Born 1978, Gisborne
Lives in Wellington

Education

2004 Master of Fine Arts (Painting), University of Canterbury
1999 Bachelor of Media Arts (Painting), Wintec

Solo Exhibitions

2008 *The Beautiful and the Damned*, City Gallery, Wellington
Twilight Falls, Open Window Series, Govett-Brewster Gallery, New Plymouth
Brave Days, Enjoy Gallery, Wellington
2007 *Down from the Nightlands*, Sarjeant Gallery, Wanganui
The Quietening, Jonathan Smart Gallery, Christchurch
2005 *Jitterbug*, Jonathan Smart Gallery, Christchurch
The Wanderers, Michael Lett Gallery, Auckland
2004 *Mini Migration*, 'Bloom', Gallery 64zero3, Christchurch
The Big Rock Candy Castle, The Kiosk, Christchurch
The Flower People, 'Sampler Series', Physics Room, Christchurch
Scenic Vista, Blue Oyster Gallery, Dunedin
2003 *Picnic*, Platform 01, Hamilton
Shabby Dresser, Fresh Gallery, Christchurch
Cardboard Tales, High Street Project, Christchurch

Selected Group Exhibitions

2008 *Baltic Wanderer*, SIM House, Reykjavík, Iceland
Passing Night, ROSL Scholars Exhibition, London
Private Park, Mary-Newton Gallery, Wellington
2007 *The Cloud Watchers*, Wanganui Review Show, Sarjeant Gallery, Wanganui
Astray, Ramp Gallery, Hamilton
At the Violet Hour, 'Who's Afraid of the Big Bad Wolf', Te Tuhi Centre for the Arts, Auckland
2006 *Beyond Nowhere Diorama's*, 'Triple Candy', Jonathan Smart Gallery, Christchurch
Beyond Nowhere, 'Out of Erewhon', Christchurch Art Gallery
2004 *One Day on Cone Island*, 'Craft is Love', Jonathan Smart Gallery, Christchurch
World of Lollipop, 'Little Things Take Time', George Fraser Gallery, Auckland
Miniature Theatres, 'Duets', Ramp Gallery, Hamilton
Candy Mountain, 'Remember New Zealand', São Paulo Biennial, Brazil
The Big Rock Candy Castle, Waikato National Art Awards, Hamilton
Tea Party, 'The New Alchemists', NZ Art Awards in Secondary Materials, CoCA Gallery, Christchurch
Binoculars (Shabby Dresser series), 'Talk to the Dumbness', Rm 103, Auckland

The Sky People, 'Urban Legends', Bartley Nees Gallery, Wellington
Land of Sweet, 'Show Stoppers', Jonathan Smart Gallery, Christchurch
Hill, 'Mr and Mrs Pink's Fabulous Collection', High Street Project, Christchurch; Blue Oyster Gallery, Dunedin
2003 *Roaming Homes*, 'Labrats', Edison Hall, Christchurch
Lollipop, 'Follow the White Rabbit', Artspace, Auckland
Suave Suites, 'Reaching Out, Calling New Age Power', Enjoy Gallery, Wellington

Residencies

2008 SIM Iceland
2007 Tylee Cottage residency (Sarjeant Gallery, Wanganui)
2007 Royal Overseas League Residency (London/Scotland)

Awards

2006 Olivia Spencer Bower Foundation Art Award, Christchurch

Julia Morison

Born 1952, Pahiatua
Lives in Christchurch

Education/Employment

1999–2006 Senior Lecturer in Painting, University of Canterbury
1990–99 Lived and worked in Oyes, France
1975 Diploma of Fine Arts (Honours), University of Canterbury
1972 Diploma in Graphic Design, Wellington Polytechnic

Selected Solo Exhibitions

2007 *Gargantua's Petticoat*, Two Rooms Gallery, Auckland
2006–07 *Julia Morison: A loop around a loop*, Christchurch City Art Gallery; Dunedin Public Art Gallery
2005 *Gobsmack & Flabbergast*, Gallery 64zero3, Christchurch
Teaching Aids, Gus Fisher Gallery, University of Auckland
2004 *Space Invaders*, Lopdell House Gallery, Waitakere City
2003 *No Names for Things No String for #1*, Jonathan Smart Gallery, Christchurch
2002 *Angels & Flies*, Jonathan Smart Gallery, Christchurch
From the Book of Shadows, Jensen Gallery, Auckland
1999 *Madame & the Bastard* (collaboration with Heather Straka), Dunedin Public Art Gallery
Material Evidence: 100-Headless Woman (collaboration with Martin Grant),

1998 *Material Evidence: 100-Headless Woman* (collaboration with Martin Grant), City Gallery, Wellington
1997 *[&] & 1, m0n0chr0mes #4*, Jensen Gallery, Auckland
1, m0n0chr0mes #3: Conversing with Loplop, Jonathan Smart Gallery, Christchurch
Material Evidence: 100-headless woman (collaboration with Martin Grant), Govett-Brewster Art Gallery, New Plymouth
Stuttering, Gow Langsford Gallery, Auckland
1996 *1, m0n0chr0mes #2*, McDougall Art Annex, Christchurch
1995 *1, m0n0chr0mes #1*, New Gallery, Auckland
1991 *Amalgame*, Cadran Solaire, Troyes, France
1990 *Decan: A work in ten parts*, Artspace, Auckland; Hocken Library, Dunedin; CSA Gallery, Christchurch

Selected Group Exhibitions

2005 *Timeless Land Gala Concert* (included *Celestial Bodies*, in collaboration with John Christoffels and Chris Cree-Brown), Applaud 2005, Christchurch Arts Festival, Christchurch Town Hall
2004 *Public/Private: Tumatanui/Tumataiti*, Second Auckland Triennial, Auckland Art Gallery
2003 *Signs and Wonders He Tohu He Ohorere: Supernatural encounters through art and taonga*, Museum of New Zealand Te Papa Tongarewa, Wellington
2001 *Dark Plain*, Christchurch Arts Festival, CoCA Gallery, Christchurch
Prospect 2001, City Gallery, Wellington
2000 *The Numbers Game: Art and mathematics*, Adam Art Gallery, Wellington
1999 *Jardins Secrets: KP5 Biennale* (collaboration with Martin Grant), Hôpital Charles Foix, Paris
1998 *L'Exposition de L'Ecole des Beaux Arts*, L'Ancien College des Jesuites, Reims, France
Adelaide Festival (collaboration with Martin Grant), Artspace, Adelaide
1995 *A Very Peculiar Practice: Aspects of recent New Zealand painting*, City Gallery, Wellington
1994 *Localities of Desire: Contemporary art in an international world*, Museum of Contemporary Art, Sydney
1993 *Alter/Image: Feminism and representation in New Zealand art 1973–1993*, City Gallery, Wellington; Auckland Art Gallery
Mediatrix: New work by seven women artists, Artspace, Auckland; Govett-Brewster Art Gallery, New Plymouth
White Camellias: A century of art making by Canterbury women, Robert McDougall Art Gallery, Christchurch
1992 *Headlands: Thinking through New Zealand art*, Museum of Contemporary Art, Sydney; National Art Gallery, Wellington; Dunedin Public Art Gallery; Auckland Art Gallery
The Boundary Rider, 9th Biennale of Sydney

1990 *[…] exuberant, floating, dancing, mocking, childish and blissful art*, George Fraser Gallery, Auckland
Now See Hear! Art, language and translation, City Gallery, Wellington
United New Zealand Modern Masters 11 Collection, Eastern Southland Gallery, Gore; Southland Museum and Art Gallery, Invercargill; Forrester Gallery, Oamaru

1989 *Canterbury Belles*, Robert McDougall Art Gallery, Christchurch (toured to Wellington, Hamilton, Auckland, New Plymouth, Gisborne and Timaru)

1988 *Exhibits: The Museum Display and the Encyclopedia Plate*, National Art Gallery, Wellington; Artspace, Auckland

1987 *ARX '87: Australia and Regions Artists' Exchange*, Perth Institute of Contemporary Art
Sex and Sign, Artspace, Auckland; Govett-Brewster Art Gallery, New Plymouth; City Gallery, Wellington; Manawatu Art Gallery; Hawke's Bay Art Gallery and Museum, Napier; Dunedin Public Art Gallery; Robert McDougall Art Gallery, Christchurch; Sarjeant Gallery, Wanganui

1986 *Content/Context: A survey of recent New Zealand art*, National Art Gallery, Wellington

Awards
2005 New Zealand Arts Foundation Laureate
1994 CNZ grant
1990 New Zealand Möet & Chandon Fellowship
1989 QEII Arts Council grant
1988 Frances Hodgkins Fellowship, University of Otago

Don Peebles

Born 1922, Taneatua
Lives in Christchurch

Education/Employment
1965–86 Lecturer/Reader, School of Fine Arts, University of Canterbury

1947–50 Art School, Wellington Technical College
1951–53 Julian Ashton School of Art, Sydney

Solo Exhibitions
2007 Works, Campbell Grant Galleries, Christchurch
2006 *Images, New & Recent Works*, Diversion Gallery, Blenheim
2005 *Don Peebles at 83*, Campbell Grant Galleries, Christchurch
2004 Recent Painting, Artis Gallery, Auckland
2003 *Scale & Dimension*, Diversion Gallery, Blenheim
2002 Recent Work, Janne Land Gallery, Wellington
2001 Recent Works, Artis Gallery, Auckland

2000 Works, Janne Land Gallery, Wellington
1999 Drawings, Janne Land Gallery, Wellington
Relief and Painting 1999, Artis Gallery, Auckland
Works, Brooke/Gifford Gallery, Christchurch
1998 Solo Exhibition, Lesley Kreisler Gallery, New Plymouth
Paintings & Drawings, University of Canterbury, Christchurch
Recent Painting, Artis Gallery, Auckland
1997 *Don Peebles: The Harmony of Opposites*, Auckland Art Gallery; Manawatu Art Gallery, Palmerston North; City Gallery, Wellington
Works, Artis Gallery, Auckland
Painting & Relief Works, Janne Land Gallery, Wellington
In Perspective, Grove Mill Winery, Blenheim
1996 *Don Peebles: The Harmony of Opposites*, Robert McDougall Art Gallery, Christchurch
Works, Brooke/Gifford Gallery, Christchurch
1995 Recent Small Works, Artis Gallery, Auckland
1994 Drawings, Brooke/Gifford Gallery, Christchurch
1993 Works, Hawke's Bay Exhibition Centre, Hastings
Scale and Dimension, Brooke/Gifford Gallery, Christchurch
1992 *Don Peebles: Paintings and Drawings*, Janne Land Gallery, Wellington
Works, Centre for Contemporary Art, Hamilton
1991 *Don Peebles: Paintings and Drawings*, Artis Gallery, Auckland
1989 *Don Peebles*, Janne Land Gallery, Wellington
1988 *Don Peebles: Drawings of the 80s and Recent Paintings*, Robert McDougall Art Gallery, Christchurch
Drawings, Canvas, Reliefs, Constructions, Lesley Kreisler Gallery, New Plymouth
Paintings, University of Canterbury, Christchurch
1987 *Don Peebles: Personal Sketches*, Gingko Gallery, Christchurch
1986 *Don Peebles: Works on Paper*, Janne Land Gallery, Wellington
1985 *Don Peebles: Recent Works*, Janne Land Gallery, Wellington
Don Peebles: Drawings of the Eighties, Suter Art Gallery, Nelson (toured)
1983 *Artist in Focus: Drawings and Paper Reliefs*, Auckland Art Gallery
Paintings and Works on Paper, Robert McDougall Art Gallery, Christchurch
1982 *Paintings, Reliefs, Drawings 1962–1981*, Robinson and Brooker Galleries, Christchurch
1981 *Don Peebles: Paintings*, National Art Gallery, Wellington
Don Peebles: Works on Paper, Gingko Gallery, Christchurch

1980 *Don Peebles*, Govett-Brewster Art Gallery, New Plymouth
Nine Recent Works, Auckland Art Gallery
1979 Don Peebles: His Latest Work, Elva Bett Gallery, Wellington
Paintings and Reliefs by Don Peebles, Suter Art Gallery, Nelson
Recent Work by Don Peebles, Robert McDougall Art Gallery, Christchurch
1977 *Relief Constructions in Canvas and Wood*, Barry Lett Galleries, Auckland; Victoria University, Wellington
1973 *Paintings, Constructions, Drawings* by Don Peebles, CSA Gallery, Christchurch
1973 *Don Peebles Retrospective*, Dowse Art Museum, Lower Hutt
1972 *Don Peebles: Recent Paintings*, Barry Lett Galleries, Auckland
1969 *Don Peebles: Paintings*, Barry Lett Galleries, Auckland
1967 *Peebles: Auckland Festival Exhibition*, Barry Lett Galleries, Auckland
1964 Centre Gallery, Wellington
1954 Architectural Centre Gallery, Wellington

Selected Group Exhibitions
2002 *Contemporaries 1960–1979*, Govett-Brewster Gallery, New Plymouth
2000 Collectors Choice, Museum of New Zealand Te Papa Tongarewa, Wellington
1995 *Abstraction in the '70s*, Artis Gallery, Auckland
1994 *The '50s Show*, Auckland Art Gallery
1993 *Paper and Print: 15 Canterbury Artists*, Kurashiki, Japan
1992 *International Fax Exhibition*, Denver, Colorado
1991 *Cross Currents*, from the Chartwell Collection, Contemporary New Zealand and Australian Art, Waikato Museum of Art and History, Hamilton
Exhibition of UK Works, National Art Gallery (Shed 11), Wellington
1990 *Goodman Suter Biennale* (guest artist), Suter Art Gallery, Nelson
Carpet Concepts, including three rugs designed by Peebles, Dilana Rugs, Christchurch; Gretz Gallery, Melbourne
1988 *The Artist Collection*, including three rugs designed by Peebles, Dilana Rugs, Christchurch; New Zealand Embassy, Washington
1986 *A Piece of Art for Peace*, Robert McDougall Art Gallery, Christchurch
Content/Context, National Art Gallery (Shed 11), Wellington
1985 *Extracts: Three decades of New Zealand art: 1940–1970*, National Art Gallery, Wellington
1984 *Paperchase*, Robert McDougall Art Gallery, Christchurch

1983 *Aspects of Recent New Zealand Art: The Grid*, Auckland City Art Gallery (toured)
1981 *Gordon H. Brown's Collection*, Manawatu Art Gallery, Palmerston North
Conformity and Dissension: New Zealand Painting 1940–1960 RKS, QEII Arts Council (toured)
1978 *Platforms*, CSA Gallery, Christchurch
1977 *Formal Abstraction in New Zealand*, National Art Gallery, Wellington
1974 *Kim Wright Collection of New Zealand Paintings*, Govett-Brewster Art Gallery, New Plymouth
1971 *Ten Big Paintings*, Auckland Art Gallery
1970 *Kim Wright Collection*, Govett-Brewster Art Gallery, New Plymouth
New Zealand Pavilion, Expo '70, Tokyo
Contemporary Painting in New Zealand: 12 Artists, Smithsonian Institution, Washington
1968 *Ten Years of New Zealand Painting in Auckland*, Auckland City Art Gallery
Five New Zealand Artists, Bonython Art Gallery, Sydney
1965 *Contemporary Painting in New Zealand*, Queen Elizabeth Arts Council, London
1964 *Contemporary New Zealand Painting 1964*, Auckland City Art Gallery
New Zealand Contemporary Paintings and Ceramics, QEII Arts Council, Japan, India and South-East Asia
1963 *Contemporary New Zealand Painting 1963*, Auckland City Art Gallery
1962 *London Group 62*, Art Federation Galleries, London
Collages and Constructions, 15th Aldeburgh Festival, England
Commonwealth Art Today, Commonwealth Institute, London
1961 *Painting from the Pacific*, Auckland Art Gallery
Penwith Art Society, Penwith Gallery, St Ives, Cornwall
Summer Exhibition, Fore Street Gallery, St Ives, Cornwall
1959 *Eight New Zealanders III*, Auckland Art Gallery
1959 *Festival Exhibition of Contemporary Painting*, Wellington
1948–51 Annual Exhibition, New Zealand Academy of Fine Arts, Wellington

Awards
2007 Arts Foundation of New Zealand Icon Award
2003 Honorary Doctorate, University of Canterbury, Christchurch
1999 New Zealand Order of Merit (ONZM)
1960–62 Association of New Zealand Art Societies Fellowship award (2 years)

Séraphine Pick

Born 1964, Kawakawa, Bay of Islands
Lives in Wellington

Education/Employment
1997–98 Lecturer in Painting, Elam School of Fine Arts, University of Auckland
1991 Diploma of Teaching, Christchurch College of Education
1987 Graduated Bachelor of Fine Arts, University of Canterbury, Christchurch

Selected Solo Exhibitions
2008 *After Image*, Mahara Gallery, Kapiti Coast; Sarjeant Gallery, Wanganui
Fall and Trip Hazards, Michael Lett Gallery, Auckland
Portraits, Brooke/Gifford Gallery, Christchurch
2007 *Burning the Furniture*, Hamish McKay Gallery, Wellington
Paintings, Ramp Gallery, Hamilton
2006 *Hideout*, Michael Lett Gallery, Auckland
2005 *Painted Faces*, Hamish McKay Gallery, Wellington
Shared Air, Kaliman Gallery, Sydney
Works, Michael Lett Gallery, Auckland
2004 Works, Michael Lett Gallery, Auckland
Future Ghosts, Hamish McKay Gallery, Wellington
No Rest for the Wicked, Brooke/Gifford Gallery, Christchurch
2003 *My Life and Death Trip*, Michael Lett Gallery, Auckland
Portraits, Brooke/Gifford Gallery, Christchurch
2002 New Paintings, Brooke/Gifford Gallery, Christchurch
Paintings, Hamish McKay Gallery, Wellington
2000 *Earthly Possessions*, Hamish McKay Gallery, Wellington
Where Have You Been?, Hocken Library, Dunedin
Private Gardens, Anna Bibby Gallery, Auckland
1999 Recent Paintings, Anna Bibby Gallery, Auckland
Astral Plains, Hamish McKay Gallery, Wellington
New Paintings, Brooke/Gifford Gallery, Christchurch
Who Do You Think You Really Are?, window installation, Auckland Art Gallery
1998 Recent Painting, Brooke/Gifford Gallery, Christchurch
Scratching Skin, McDougall Art Annex, Christchurch; Dunedin Public Art Gallery
Among Strangers, window installation, Hungry Eyes Series, Fiat Lux Gallery, Auckland
Naked, Anna Bibby Gallery, Auckland
Small Things, Lesley Kriesler Gallery, New Plymouth
1997 *Possibly*, Anna Bibby Gallery, Auckland
Looking Like Someone Else, Manawatu Art Gallery, Palmerston North

I Wish (with Michael Harrison), Hamish McKay Gallery, Wellington
1996 *Wonderlust*, Anna Bibby Gallery, Auckland
Impulse, Brooke/Gifford Gallery, Christchurch
Recent Paintings, Hamish McKay Gallery, Wellington
1995 *Unveiled*, City Gallery, Wellington
In the Flesh, Hamish McKay Gallery, Wellington
Recent Paintings, Claybrook Gallery, Auckland
1994 *Shadow Play*, Claybrook Gallery, Auckland
Headspace, Brooke/Gifford Gallery, Christchurch
Paintings and Drawings, Hamish McKay Gallery, Wellington
1993 Recent Works, Hamish McKay Gallery, Wellington
1992 New Works, Brooke/Gifford Gallery, Christchurch
1991 Paintings and Drawings, Brooke/Gifford Gallery, Christchurch
1989 *Almost But Not Quite*, CSA Gallery, Christchurch

Selected Group Exhibitions
2006 *Recovered Memory*, Suter Art Gallery, Nelson
Four Artists, Hamish McKay Gallery, Wellington
2005 Nada Art Fair, Michael Lett Stand, Miami
Commodity & Delight: Views of home, Sarjeant Gallery, Wanganui
Hothouse, Dunedin Public Art Gallery
2004 *Prospect*, Adam Art Gallery, Wellington
Interior World, Physics Room, Christchurch
2003 *Opening Exhibition*, Christchurch Art Gallery
Portraiture: The art of social commentary, Te Tuhi: The Mark, Auckland
2002 *Red White & Black*, Anna Bibby Gallery, Auckland
2001 *Multistylus Programme: Recent Chartwell acquisitions*, Auckland Art Gallery
Fabrication, Dunedin Public Art Gallery
Beyond the Surface: Kim Pieters, Maryrose Crook, Séraphine Pick, Susan Ballard, Dunedin Public Art Gallery
Prospect 2001: New Art New Zealand, City Gallery, Wellington
Bright Paradise: Exotic history and sublime artifice, 1st Auckland Triennial
Alive: Still life into the 21st century, Adam Art Gallery, Wellington
2000 *Parihaka: The art of passive resistance*, City Gallery, Wellington
Te Ao Tawhito/Te Ao Hou: Old Worlds/New Worlds, Art Museum of Missoula, Missoula, Montana; Maui Arts Center, Hawaii
25th Anniversary Exhibition, Brooke/Gifford Gallery, Christchurch
Canterbury Paintings in the 1990s, Robert McDougall Art Gallery, Christchurch
1999 *Fear and Beauty*, Suter Art Gallery, Nelson

Home and Away: Contemporary Australian and New Zealand art from the Chartwell Collection, Auckland Art Gallery; Govett-Brewster Art Gallery, New Plymouth; Waikato Museum of Art and History, Hamilton; Manawatu Art Gallery, Palmerston North; City Gallery, Wellington; Dunedin Public Art Gallery

1998 *Skywriters and Earthmovers*, McDougall Art Annex, Christchurch
Leap of Faith: Contemporary New Zealand art 1998, Govett-Brewster Art Gallery, New Plymouth

1997 *Now Showing: Artists go to the movies*, Film Centre, Wellington (toured)
The Chartwell Collection: A Selection, Auckland Art Gallery

1996 *Visa Gold Art Award*, City Gallery, Wellington; Auckland Art Gallery
Drift North, McDougall Art Annex, Christchurch
Pins and Needles: Eight Christchurch artists, Suter Art Gallery, Nelson

1995 *Scrum*, Claybrook Gallery, Auckland
A Very Peculiar Practice: Aspects of recent New Zealand painting, City Gallery, Wellington
Residency No 9, Knsm Gallery, Amsterdam
Visa Gold Art Award, City Gallery, Wellington

1994 *Giovanni Intra/Séraphine Pick*, Dunedin Public Art Gallery
Striptease, Teststrip Gallery, Auckland

1993 *Visa Gold Art Award*, City Gallery, Wellington
Opening Up The Book, Manawatu Art Gallery, Palmerston North
From Liquid Darkness, Dunedin Public Art Gallery
Women's Lives, McDougall Art Annex, Christchurch
White Camellias, Robert McDougall Art Gallery, Christchurch

1992 *Prospect Canterbury*, Robert McDougall Art Gallery, Christchurch
Four Christchurch Artists, Claybrook Gallery, Auckland
Motif/Motive, CSA Gallery, Christchurch
Canvassing South, Gow Langsford Gallery, Wellington
Embody, CSA Gallery, Christchurch

1991 *Preparations*, Brooke/Gifford Gallery, Christchurch
Recognitions, McDougall Art Annex, Christchurch

Residencies
1999 Frances Hodgkins Fellow, University of Otago, Dunedin
1995 Rita Angus Cottage Residency, Wellington

Awards
1997 CNZ grant
1995 QEII Arts Council grant
1994 Olivia Spencer Bower Foundation Art Award

Phil Price

Born 1965, Nelson
Lives in Christchurch

Education/Employment
2005– Phil Price studio
2004 One-year sabbatical from teaching to travel through Europe and develop new work
1993–2003 Art teacher, Christ's College, Christchurch
1998 Art teacher, Rangiora High School
1996–97 Project manager, Neil Dawson sculpture studio Large-scale projects in NZ, Australia, Malaysia, Japan
1995 Composite engineer, Britten motorcycle company
1994 Developed and built family home and studio in Amberley, North Canterbury
1992 Diploma of Education (Secondary), Christchurch College of Education
1990–91 Various self-motivated projects, including composite sporting products design and manufacture, set design/build, stage management, shop and bar design/build
1984–89 Bachelor of Fine Arts (Sculpture), University of Canterbury

Solo Exhibitions
2008–09 *Fulcrum*, McClelland Sculpture Park and Gallery, Melbourne
2008 *Fulcrum*, Amisfield Winery, Lake Hayes, Queenstown; Cable Bay, Waiheke Island
2004 *Phil Price*, Campbell Grant Galleries, Christchurch
2003 *Could This Be Me?* Bowen Galleries, Wellington
2002 *Who?* Campbell Grant Galleries, Christchurch
2000 *2000 MK1*, Campbell Grant Galleries, Christchurch
Come in and Close the Door, Physics Room, Christchurch
1998 *Card Entry*, Campbell Grant Galleries, Christchurch
Revelations, Campbell Grant Galleries, Christchurch
1992 Recent Work, CSA Gallery, Christchurch
1991 *Jubespace*, McDougall Art Annex, Christchurch
1989 *Black on Yellow, White on Blue*, CSA Gallery, Christchurch

Group Exhibitions
2005 International Sculpture Survey, McClelland Sculpture Park and Gallery, Melbourne
Sculpture on the Gulf, Waiheke Island
2004 SCAPE Art & Industry Urban Arts Biennial '04, Deans Bush, Christchurch
Sculpture by the Sea (invited artist), Sydney
2003 *Sculpture by the Sea* (invited artist), Sydney
Sculpture on the Gulf, Waiheke Island
2002 *Changing Spaces: New Zealand sculpture now*, New Zealand Festival, Wellington

125th Anniversary Exhibition, CoCA Gallery, Christchurch
2001 *Prospect 2001 New Art*, City Gallery, Wellington
1999 *Evisible*, Christ's College, Christchurch
1996 *H 20*, Dowse Art Museum, Wellington
1992 *Prospect Canterbury*, Robert McDougall Art Gallery, Christchurch
1991 *Vogue Vague*, CSA Gallery, Christchurch

Public Sculpture
2009 *Organism*, Victoria University, Wellington
2008 *Angel Wings*, Canberra
2008 *Dinornis maximus*, Canberra
2006 *Nucleus*, City Mall, High Street, Christchurch
2005 *Knowledge*, Riccarton Library, Christchurch
Ratytus, McClelland Sculpture Park, Melbourne
2004 *Zephyrometer*, winner, Meridian Energy Great Wellington Wind Sculpture Project, Cobham Drive, Wellington
2003 *Cytoplasm*, Waiheke Island, relocated to The Viaduct, Auckland, 2004
Dancer, Gow Sculpture Park, Waiheke Island
2002 *Protoplasm*, Lambton Quay, Wellington
2001 *Scribble*, Collection of Sir Miles Warren, Ohinetahi, Christchurch
2000 *Masks*, Old Boys' Theatre, Christ's College, Christchurch
Book, Christ's College, Christchurch
1994 *Wiggly Wagon*, Hanmer Springs
Lift, Hanmer Springs
1993 *Taking Flight*, Christchurch Botanic Gardens

Eion Stevens

Born 1952, Dunedin
Lives in Lyttelton, Christchurch

Education/Employment
1998 Moved to Christchurch
1997 Travelled to Europe
1978 Travelled to Europe
1974–75 Studied at Exeter College of Art, Devon, England
1973 Graduated (Hons) from Otago Polytechnic School of Art

Solo Exhibitions
2009 Diversion Gallery, Blenheim
2008 *New Work on Paper*, PaperGraphica, Christchurch
Painted Poems, Warwick Henderson Gallery, Auckland
2007 *Painted Poems*, a retrospective selection of paintings and related poems, Dunedin Public Art Gallery
2006 *Shaped Paintings*, PaperGraphica, Christchurch
Square Pictures, Warwick Henderson Gallery, Auckland
2005 New Works, Warwick Henderson Gallery, Auckland

More Paintings about Death and Hats, PaperGraphica, Christchurch

2004 Warwick Henderson Gallery, Auckland
PaperGraphica, Christchurch
Ashburton Public Art Gallery

2003 Warwick Henderson Gallery, Auckland
PaperGraphica, Christchurch

2002 Warwick Henderson Gallery, Auckland
Diversion Gallery, Blenheim

2001 Warwick Henderson Gallery, Auckland

2000 CoCA Gallery, Christchurch
Diversion Art Gallery, Blenheim
Warwick Henderson Gallery, Auckland
Ashburton Art Gallery

1999 *Survey Exhibition 1983–99*, Wallace Trust Gallery, Auckland
CoCA Gallery, Christchurch

1998 Salamander Gallery, Christchurch

1997 *Survey Exhibition 1976–96*, CoCA Gallery, Christchurch
Warwick Henderson Gallery, Auckland

1996 Gray's Studio, Dunedin

1995 Warwick Henderson Gallery, Auckland
Salamander Gallery, Christchurch

1994 Canterbury Gallery, Christchurch

1993 Brooker Gallery, Wellington

1992 Canterbury Gallery, Christchurch
Warwick Henderson Gallery, Auckland

1991 Aero Club Gallery, Port Chalmers

1990 Brooker Gallery, Wellington

1989 Dunedin Public Art Gallery

1988 Brooker Gallery, Wellington

1987 Robert McDougall Art Gallery, Christchurch

1986 Brooker Gallery, Wellington

1984 Forrester Gallery, Oamaru
Janne Land Gallery, Wellington

1983 Bosshard Gallery, Dunedin
RKS Art, Auckland

1982 RKS Art, Auckland
Dunedin Public Art Gallery
Janne Land Gallery, Wellington

1981 RKS Art, Auckland

1980 Denis Cohn Gallery, Auckland

1979 Brooke/Gifford Gallery, Christchurch
Galerie Legard, Wellington
Denis Cohn Gallery, Auckland

Philip Trusttum

Born 1940, Raetihi
Lives in Christchurch

Education/Employment

2002 Moved to Christchurch to live and work

1998 First NZ artist to be reviewed in the *New York Times*

1989 Travelled to the US

1986 Moved to Waimate (Canterbury)

1984 Travelled to Europe and took part in ANZART at the Edinburgh Festival
Travelled to exhibit at the Jill Kornblee Gallery on 57th Street, New York

1980–81 Travelled to the US

1975 Travelled to Europe
Travelled to Europe and the US (nine months)

1967 Lived in Australia

1966 Fire destroyed most work of 1965–66, in transit to Sydney

1964 Graduated Diploma of Fine Arts, University of Canterbury

Selected Solo Exhibitions

2008 Dick Bett Gallery, Sydney
Milbank Gallery, Wanganui
Brett McDowell Gallery, Dunedin
WOW Gallery, Picton
CoCA Gallery, Christchurch

2007 Milbank Gallery, Wanganui
Mahara Gallery, Waikanae
Eastern Southland Gallery, Gore

2006 Gallery Thirty Three, Wanaka
Marshall Seifert Gallery, Dunedin
Etchings, PaperGraphica, Christchurch
10 Mussorgsky Paintings, Sarjeant Gallery, Wanganui
Dick Bett Gallery, Sydney
5.30am, Ng Gallery, Christchurch
10 Paintings, Chan Liu Gallery, Tao Yuan City, Taiwan
Boys' Toys, Ng Gallery, Christchurch
Warwick Henderson Gallery, Auckland

2005 Scott Ormond Gallery
Gnomus Paintings, Ng Gallery, Christchurch
Left Bank Gallery, Greymouth
Just William Paintings, Ng Gallery, Christchurch;
Warwick Henderson Gallery, Auckland

2004 Janne Land Gallery, Wellington
Mussorgsky Exhibition, Otago Festival of the Arts, Dunedin; CoCA Gallery, Christchurch; University of Waikato, Hamilton
Left Bank Gallery, Greymouth
Pictures at Exhibitions, Warwick Henderson Gallery, Auckland

2003 Warwick Henderson Gallery, Auckland
Port Gallery, Port Chalmers, Otago
Ng Gallery, Christchurch

2002 Port Gallery, Port Chalmers, Otago
Objects and Images, Warwick Henderson Gallery, Auckland
West Bank Gallery, Greymouth

Remix, Sarjeant Art Gallery, Wanganui
Mowing, CoCA Gallery, Christchurch
Everymans Castle II, Ashburton Art Gallery

2001 *Working Wonders*, Dunedin Public Art Gallery

2000 *Drawings for Passport to the New Millennium*, CoCA Gallery, Christchurch

1999 *I Do My Own Ironing*, Campbell Grant Gallery, Christchurch
Warwick Henderson Gallery, Auckland
James Wallace Art Gallery, Auckland

1998 *Motif Series*, Sarjeant Gallery, Wanganui; James Wallace Art Gallery, Auckland; Art Gallery, Napier
Madame is Blasé, CoCA Gallery, Christchurch
Dress for Tennis, SOFA Gallery, Christchurch
Campbell Grant Gallery, Christchurch

1997 *Motif Series*, CoCA Gallery, Christchurch
Grove Mill Winery, Blenheim
Campbell Grant Gallery, Christchurch
Wallace Collection, Art Gallery, Whangarei; Art Gallery, Rotorua
90 Space Art, Wellington
Aigantighe Art Gallery, Timaru

1996 *Wallace Collection*, Custom House, Auckland
Janne Land Gallery, Wellington

1995 The Loft Gallery, Christchurch (Moved to Tea Kiosk, Riccarton Racecourse)
Milford House, Dunedin
Art Gallery, Ashburton
Small Gallery, Timaru

1994 James Wallace Gallery, Auckland
Sarjeant Gallery, Wanganui
Judith Anderson Gallery, Auckland

Selected Group Exhibitions

2007 Group Show, Mahara Gallery, Kapiti

2006 *10 Paintings*, Chan Liu Gallery, Tao Yuan City, Taiwan

2005 Group Show, Scott Ormond Gallery, Napier

2003 *Trusttum with John Himmelarb*, CoCA Gallery, Christchurch
Pictures at an Exhibition, concert music and art event (with organist Martin Setchell), Christchurch Town Hall

2000 *Art Attack*, CoCA Gallery, Christchurch

1999 *Seriously Playful 1*, CoCA Gallery, Christchurch

1998 *BNZ Art Collection*, City Gallery, Wellington
Patricia Bosshard Browne Collection, Dunedin Public Art Gallery
10 x 10, Warwick Henderson Gallery, Auckland

1995 Milford Gallery, Dunedin

1994 *Child's Play*, Robert McDougall Art Gallery, Christchurch
Taking Stock of the 90s, Sarjeant Gallery, Wanganui
South Canterbury Artists 5, Aigantighe Art Gallery, Timaru

1992 *Multiples*, Robert McDougall Art Gallery,
Christchurch
1991 *Chair Exhibition*, CSA Gallery, Christchurch
Aigantighe Art Gallery, Timaru
1989 Brooker Art Gallery, Wellington
1986 *The Word Gallery*, Suter Art Gallery, Nelson
Content/Context, National Art Gallery, Wellington
Montana Lindauer Art Competition, Auckland
Karaka, Loft Gallery, Auckland, Karaka Yearling Sales
1985 *New Zealand New York*, 22 Wooster Street, New York
Better than Collecting Dust, Manawatu Art Gallery,
New Plymouth
Big Paintings, CSA Gallery, Christchurch
1984 *ANZART: Australian and New Zealand Arts in
Edinburgh*, International Festival, Edinburgh
Trusttum with Don Driver, Sarjeant Gallery, Wanganui
1983 *Installation Art*, Govett-Brewster Art Gallery, New
Plymouth
The Prospect Collection of Contemporary NZ Painting,
Centre Gallery, Hamilton
Summer '83, Janne Land Gallery, Wellington
1982 *The Fourth Biennial of Sydney*, Art Gallery of NSW,
Sydney
Vision of Disbelief, Dunedin Public Art Gallery
New Zealand Drawing 1982, Janne Land Gallery,
Wellington
Me by Myself: The self portrait, National Art Gallery,
Wellington
1981 *Smith, Alvarez, Trusttum*, Govett-Brewster Art Gallery,
New Plymouth
Gordon H. Brown's Collection, Manawatu Art Gallery,
Palmerston North
1980 Exhibition of original paintings from Fletcher House,
Society of Arts Galleries, Auckland

Selected Commissions

2006 Carpet for James Wallace, Auckland
2005 Stained glass window for St Mathew's, Auckland
1999 Year 2000 Tapestry Design (15 m x 3 m), Turning
Point 2000, Christchurch
Passport to the New Millennium (84 m x 2.4 m), NCC
(NZ) Ltd, Christchurch
Stained glass millennium window, Ashburton Art
Gallery
1995 Mural, SkyCity Casino (17 metres high), Auckland
Internal window screen, James Wallace, Auckland
1986–87 Stained glass windows, Unisys House, Wellington
Windows, St Thomas's Anglican House, Christchurch
Jubilee Window, Cathedral of the Blessed Sacrament,
Christchurch
Wall hanging, Civic Chambers, Rotorua
Windows, Dr Alex Baird, Christchurch
1982 Stairwell installation, James Wallace, Auckland

Awards

2000 Pollock Krasner Foundation grant
1972 QEII Arts Council grant
1966 QEII Arts Council grant (travel to Australia)

Ronnie van Hout

Born 1962, Christchurch
Lives in Melbourne

Education/Employment

1998–99 Master of Fine Arts, RMIT University,
Melbourne
1995 Completed Computer Aided Design course (part
time), Christchurch Polytechnic
1989–91 Photography, Photo Access, Christchurch
1984–85 Printmaking techniques with Jill McIntosh,
Wellington Arts Centre
1980–82 School of Fine Arts (Film Studies), University of
Canterbury, Christchurch

Selected Solo Exhibitions 2004–09

2009 *Fallenness*, Ocular Lab Inc., Melbourne
2008 *A Loss, Again*, Te Papa Sculpture Terrace, Museum of
New Zealand Te Papa Tongarewa, Wellington
Hold That Thought, Hamish McKay Gallery,
Wellington
Bed/Sit, Artspace, Sydney
2007 *Ersatz*, Ivan Anthony Gallery, Auckland
2006 *Sleep Less*, Darren Knight Gallery, Sydney; Silvershot,
Melbourne
Jingle Bowels, Hamish McKay Gallery, Wellington
2005 *The Disappearance*, Ivan Anthony Gallery, Auckland
Now + Then = Nothing, Hamish McKay Gallery,
Wellington
Ersatz, Kunstlerhaus Bethanien, Berlin
2004 *I've Abandoned Me* (toured Dunedin, Auckland,
Wellington, Palmerston North)

Selected Group Exhibitions 2004–09

2009 *F for Fake*, Te Tuhi Centre for the Arts, Auckland
*Too Much of Me: 7 Paths through the absurd, (with
detour)*, Monash University Museum of Art,
Melbourne
2008 *Primary Views*, Monash University Museum of Art,
Melbourne
Lost & Found: An archaeology of the present, TarraWarra
Biennial, Victoria
2007 *K*, Institute of Contemporary Art, Newtown, Sydney
The Visitors, Penrith Regional Gallery, NSW
A Room Inside, Ian Potter Museum of Art, University
of Melbourne
Sculpture, Darren Knight Gallery, Sydney
Eye to I, Ballarat Fine Art Gallery, Victoria
Fronting Up, Enjoy Gallery, Wellington

Relentless Optimism, Carlton Hotel
2006 *High Tide: New currents in art from Australia and New
Zealand*, Zacheta National Gallery of Art, Warsaw;
Contemporary Art Centre (CAC), Vilnius, Lithuania
ReBoot: The Jim and Mary Barr Collection, Dunedin
Public Art Gallery (toured)
Masquerade: Representation & the self in contemporary art,
Museum of Contemporary Art, Sydney
Don't Misbehave, SCAPE Biennial of Public Art,
Christchurch
*Recovered Memory: The Fourth Goodman-Suter
Contemporary Art Project*, Suter Art Gallery, Nelson
The Inconceivable, St Paul Gallery, Auckland
Tribute, Auckland Art Gallery
Micro Macro City, Australian Pavilion, 10th
International Architecture Exhibition, La Biennale di
Venezia, Venice
Reverie, Switchback Gallery, Gippsland Centre for Art
and Design, Monash University, Melbourne.
Tomorrow Again, Artspace, Sydney
Resistance is Futile, Victorian College of the Arts
Gallery, Melbourne
2005 *Play: Portraiture & Performance in Video Art from New
Zealand and Australia*, Adam Art Gallery, Wellington;
Perth Institute of Contemporary Art
Das Unfassbare, 2YK Gallerie, Berlin
2004 *Prospect 2004*, City Gallery, Wellington
Planet B, Magazin4 Vorarlberger Kunstverein &
Bregenzer Kunstverein, Bregenz, Austria
The Walters Prize, jury-selected finalists, Auckland Art
Gallery
Coming Home in the Dark, Christchurch Art Gallery
Home Sweet Home: Works from the Peter Fay Collection,
National Gallery of Australia, Canberra (toured)
Instinct, Monash University Museum of Art,
Melbourne

Residencies

2007 Antarctic Arts Fellowship, Antarctic New Zealand
2005 Laureate Award, New Zealand Arts Foundation
2004–05 Artist in Residence, International Studio
Programme, Kunstlerhaus Bethanien, Berlin
2003–04 Artist in Residence, Massey University, Wellington
1999 Residency, International Studio Program, PS1,
New York
1995 Artist in Residence, Govett-Brewster Gallery,
New Plymouth Polytech
1994 Residency, ELBA, Nijmegen, Netherlands

Awards

2005 Laureate Artist, Arts Foundation of New Zealand
2004 Finalist, Walters Prize
1995 CNZ grant
1992 QEII Arts Council grant (travel)
1989 QEII Arts Council grant (professional development)
1986 QEII Arts Council grant (new artist)

Acknowledgements

The Canterbury Arts and Heritage Trust is grateful to all the participating artists, who are the essence of this project.

For their generous contributions of time and expertise the trust is indebted to Justin Paton (essay), Sally Blundell (artists' interviews), Diederik van Heyningen (photographs unless otherwise stated), Aaron Beehre (book and cover design), Melinda Johnston (image selection) and Professional Arts Services (project management)

Every effort has been made to correctly attribute all images in this book.

CAHT appreciates the support offered by the University of Canterbury for this publication, especially Professor Ken Strongman and Canterbury University Press publisher Rachel Scott, and warmly acknowledges assistance from the School of Fine Arts, especially Richard Bullen, Coralie Winn and Melinda Johnston, with the accompanying exhibition, *Inner Landscapes* (SOFA Gallery, 30 July 2009 to 30 August 2009). Thanks also to the Christchurch Arts Festival for including this project in its 2009 programme.